ADIRONDACK FACES

Adirondack Faces

Photographs by Mathias Oppersdorff

Text by Alice Wolf Gilborn

Foreword by Adam Hochschild

THE ADIRONDACK MUSEUM / SYRACUSE UNIVERSITY PRESS

First Edition 1991
91 92 93 94 95 96 97 98 99 6 5 4 3 2 1

The paper used in this publication meets the minimum
requirements of American National Standard for Information
Sciences—Permanence of Paper for Printed Library Materials,
ANSI Z39.48-1984. ⊗

Manufactured in the United States of America

Library of Congress Cataloging-in-Publication Data

Oppersdorff, Mathias T., 1935–
 Adirondack faces / photographs by Mathias Oppersdorff ;
text by Alice Wolf Gilborn ; foreword by Adam Hochschild.
— 1st ed.
 p. cm. — (York State books)
 ISBN 0-8156-0260-X
 1. Adirondack Mountains (N. Y.)—Biography—
Portraits. 2. Adirondack Mountains (N. Y.)—
Occupations—Pictorial works. 3. Adirondack Mountains
(N. Y.)—Biography. I. Gilborn, Alice Wolf. II. Title.
F127.A2067 1991
779'.2—dc20
[B] 90-28862
 CIP

The Adirondacks are people—not just mountains.

—William B. Bibby

CONTENTS

FOREWORD

The Tools of Their Trades

Adam Hochschild

For well over a century, the forests and lakes of the Adirondack Mountains have lured city dwellers in search of unspoiled wilderness. Among them have been many artists and photographers, from the painters Winslow Homer and Frederic Remington in the last century to the nature photographer Eliot Porter in this one. What these visitors have usually recorded is the region's extraordinary natural beauty. Some human figures do appear in the Adirondack paintings of Homer, Remington, and others, and in the glass-plate images of the early photographers who lugged heavy cameras and tripods up mountain trails, but they are usually of hunters and fishermen or of the professional guides who led these city folk into the backwoods. To the viewer who scans the Adirondack paintings and photographs found in galleries today, the region appears, except for the lone hiker or angler, largely empty of people.

For precisely this reason, the Adirondack Museum asked Mathias Oppersdorff to do the portraits that appear on the following pages. The bulk of these photographs were first exhibited at the Museum in 1989, and later at other museums in New York State. This is their first appearance in book form. Oppersdorff's assignment was to do a series of portraits of Adirondackers—not of summer visitors, but of the people who live in these mountains for all seasons of the year. Other details were mostly left to him.

The result was a collection of images far richer and more varied than anyone had expected. Some of the richness is due to the fact that Oppersdorff traveled through the Adirondacks not only with a camera, but with a tape recorder as well. Both instruments need a skilled user. Oppersdorff asked his subjects their names and ages and birthplaces, and got them to talk about their lives, about how they felt about the rugged region where they lived, and above all about their work.

Again and again these men and women give friendly advice about how to perform a necessary craft. About repairing cars that have gone through the lake ice: "The engine you've got to tear it apart right then, you can't wait. Or it'll rust." About circling your sleeping place on the forest floor with a rope "to keep the crawling creatures away because

INTRODUCTION

A Part of These Mountains

Alice Wolf Gilborn

On the august day I first saw Mathias Oppersdorff I had misgivings. There he stood like a tree on the campus of the Adirondack Museum, six feet five inches and clad in safari jacket and cravat, his commission-winning photographs tucked in a folder under his arm. He would begin to photograph the people of the Adirondacks that fall. Now he was eager to show us the results of his last project, more of those somber, dramatic images of itinerant gypsy-like people called Tinkers he had tracked across the wilds of Ireland. I wondered how he would fare in the wilds of the Adirondacks.

Exotic looking, a world traveler and free-lance photographer for *Gourmet Magazine,* Oppersdorff seemed the antithesis of the many Adirondack residents we had come to know in the fifteen years we had lived here. These were basically friendly people, though reserved at first, protective of their children, good to their neighbors, and always quick to help in a crisis. But they did not readily confide in outsiders—anyone not born in the Adirondacks—who might make demands of them. In their entire lives, some had journeyed no further than a hundred miles from their place of birth. How would they react to this tall and worldly interloper who prowled about with a camera and tape recorder asking questions about their personal lives and work?

Their revealing responses can be seen in the fifty-three faces in this book. The affinity that was somehow established between photographer and subject is even more evident in the words Oppersdorff recorded on tape, ranging from four to thirty pages each when transcribed. These interviews shattered my preconception that Adirondackers do not talk willingly to strangers. Oppersdorff's subjects openly expounded on their work, their families, life in the Adirondacks, the changes they had seen. They told jokes and anecdotes. Wisely, Oppersdorff did not ask them about local issues; he was not seeking opinions, of which Adirondackers have many, but a broader outlook. Nor was he looking for a collection of eccentric rural characters. The people he found and ultimately photographed were closely tied to their work, as he illustrates so well. And by choice or necessity, their occupations and expectations tied them just as closely to the region in which they lived.

New York's northern wilderness just as in the American West, where the measure of a man was his ability to survive, not the size of his estate. Edith Morcy, one of the Adirondackers portrayed in this book, whose father built a hotel at Fourth Lake and guided for J. P. Morgan, comments: "J. P. with all his and my dad with very little were of a kin when they were out together [fishing]. My dad liked to chew tobacco so J. P. would chew tobacco with him. And they would have a great time together."

This mutual respect between client and guide made possible by their surroundings is a key instance of the impact of the natural environment upon the men and women interviewed by Mathias Oppersdorff. Many derive their livings directly from this environment (from the "lumberwoods" as they are called) much as Adirondackers did in the last century. Ten of them work, or once did, as loggers or in related jobs such as forest management or milling logs for lumber. Others are skilled woodsmen, guides, hunters, fishermen, and trappers. Still others, builders and carpenters, use the raw materials of the forest to fashion guideboats, log cabins, and rustic furniture. Several are farmers, although they farm mostly as a gesture to tradition and earn their living primarily by other means.

The advent of the automobile in the Adirondacks early in this century had almost as great an impact on the economy as the timber industry had in the last century. With the coming of motorized vehicles and better roads, farming, which had been subsistence to begin with, became even more marginal, since goods could be trucked in from outside sources. Railroads could not compete, although passenger service survived in North Creek until 1956. Well-heeled visitors who had spent weeks or even the summer at a hotel on a lake gradually gave way to a stream of middle-class day trippers. Tourism had become a primary source of income in the Adirondacks and remains so today. These itinerant travelers require motels, service stations, and boat liveries, but the money they bring is unpredictable and seasonal. A steadier source of income for many Adirondackers is building and maintaining roads for the state highway department. Yet even this work is dictated by the weather.

More important for Adirondackers working as loggers, trucks could now carry timber out of the woods and to the mills during most of year, making river drives and the old lumberjack way of life in the woods obsolete. While forest industry companies own about half the private lands in the Adirondack Park today, all-inclusive operations, once common in the days of the woods camps and company towns, have made way for small operations that employ only a dozen or so men or that hire individual jobbers owning their own equipment. Says Fritz Pfendler, who saw the last river drive at McKeever in 1948, "You get up in the morning and get in your Cadillac and go in the woods and cut a tree down and come home."

Despite their bond to the natural world, Adirondackers, forever resourceful, display a ready fascination with the mechanical. Most can repair an engine. Derelict automobiles in yards testify to a never-ending quest for spare parts. Pickups spin across frozen lakes and snowmobiles skim through the winter woods. Pragmatic rather than theoretical, Adirondackers can employ the fruits of technology as effectively as any worker in Manhattan. To see an Adirondacker choreograph a backhoe is as inspiring as watching him land a fish. He knows his machine and its quirks as well as his counterpart in the nineteenth century knew his horse.

While they willingly embrace technology, they are not indifferent to its potential threat to their environment. Loggers who preferred horses to skidders were quick to point out to Mathias Oppersdorff the arbitrary destruction of forest growth by machines with voracious appetites. Native Adirondackers, however, do not elaborate much on the surroundings that have shaped their lives and livelihoods for generations. It is the recent and part-time residents, who have come to the Adirondacks from the outside, who are more likely to articulate their expectations. They see the region as a retreat from the stress of urban life where they can restore physical and mental health; or they value it as a place to play and hunt and practice the simple virtues of a pioneer life; or they view through the eyes of an artist its beauty, romance, and even cruelty. And if they come expecting to find a job, they find themselves in the same dilemma as long-time residents. Yet whatever their view of the Adirondacks, it is colored by their ideas of what they want the Adirondacks to be.

The faces in this book belong to people who could be anywhere, with their inconsistencies, hopes, disappointments, and ideas. But while they bear a resemblance to other rural groups, they are also individuals in a setting found nowhere else in the world. They are defined by their occupations, by the peculiarity of their political structure, and above all by their landscape. Says Bill Bibby of North Creek, "I feel a part of these mountains and I feel the mountains are a part of me."

Who, then, is a "typical" Adirondacker? In his 1983 report *Hamlets of the Adirondacks,* Roger Trancik writes, "[The] inseparable connection between man and nature bestows upon Adirondack settlements a unique sense of place." According to Lincoln Barnett, a resident and noted author of *The Ancient Adirondacks,* "No special cultural ties, no unique language or accent, no historical traditions unite the people of the towns and hamlets within the [Adirondack] Park. But they do share a firm independence, a love of the woods, and a spirit of isolationism." It can be said that these traits have been magnified by an environment where trees greatly outnumber people. Population in Hamilton County, the third largest in area in New York State and, along with Essex County, falling entirely within the boundaries of the Adirondack Park, totaled just 5,236 in 1990. In spite

of better mobility, Adirondackers contend still with long distances between towns, lack of jobs and urban amenities, poor communications, an unregenerate climate, and a tortuous topography, much as they did a century ago. These features, along with their intimacy with the wilderness, are an Adirondacker's heritage. Inherited also is a low tolerance for authority—especially that of outsiders, be it the timber man, the wealthy camp owner, or the state—that encourages a firm independence. Historical traditions may not unite Adirondack communities, but attitudes do.

What all Adirondackers possess is their love of place. "Took a ground chain, you couldn't drive me out of the Adirondacks," says Jim Riley. They are proud owners of their land; they are not tenants, nor do they consider themselves stewards of a public trust. Although many contest the regulations that are a condition of living within the Adirondack Park, they have mostly done what they have wanted with their property over the last one hundred fifty years.

But escalating values of Adirondack land may cause native Adirondackers, who are suspicious of too much change, to reexamine their way of life. Many residents perceive themselves as caught between two equally untenable factions: so-called developers, who want to turn the region into a paradise of second homes, and rigid preservationists, who wish it to revert to a mountain wilderness stripped of human habitation, without regard to existing human needs. These are exaggerated extremes. But Adirondackers have trouble discerning a middle ground.

The concept of a wide expanse of unexploited forest land whose beauty and wild character are balanced by a stable population and a controlled economy is one that most residents would endorse. Yet it is difficult for Adirondackers, who have struggled for generations to eke a living from these unforgiving mountains, to accept what seems to them a romantic view, usually espoused by newcomers and "outsiders," of a wilderness valuable for itself alone rather than for the timber, iron ore, or game it produces, or even for the few people it supports. Yet those who see the Adirondacks from this perspective have seen other areas like them eroded not so much by human greed as by lack of planning and foresight. They know, too well, that this failure to look ahead can destroy the very environment Adirondackers consider their birthright. The isolation, harsh climate, and poverty that have plagued them for almost two centuries have also been the factors that have preserved their way of life. Though anchored by occupation and attitude to the nineteenth century, they have been able to accommodate to the twentieth at their own pace. New advances in technology now allow people to live in the Adirondacks and work outside, and a rapidly growing awareness of the environment as crucial to all life not only focuses attention on the region but stresses what Adirondackers have known all along: man and nature are irrevocably joined, for better or for worse. With the advent

of the next century, the tempo of change in these seemingly changeless mountains is sure to accelerate.

That Adirondack resourcefulness will remain constant is also inevitable. In June 1987, Arthur Gates of Blue Mountain Lake, a guide, lumberman, caretaker, carpenter, and guideboat competitor who died in April 1989 at age ninety, gave Mathias Oppersdorff a summation of his life in the Adirondacks. He told how flat bottom boats supplanted guideboats for hauling supplies to camps around the lake and then, as time went on, how people put motors on the flat bottoms. "It's interesting the changes in ways of life," he reflected. "But it's a lot of good changes, a lot of good changes. And some that were not so good. But basically, as somebody asked me the other day, if you had your life to live over again what would you change in it? I said nothing. Satisfied the way it was. Yep, you know I had a good life, had a rough life sometimes, hard. You take anybody who lives in this country, if you're going to be successful, you've gotta turn your hand at different occupations. Because it's summer resort mainly, carpenter work, masonry work, anything that had to be done. . . . So I was fortunate when I was a young lad I was pretty observing, and then people—older men—were nice to me. All of them seemed to take pains to teach me. So in that way I learned to do several different things. I've got some money, got a lot of good property up here. I had a good life, wouldn't change nothin'."

Art Gates may not speak for everyone in *Adirondack Faces,* but he speaks for many.

ADIRONDACK FACES

THE REVEREND DAISY ALLEN

Daisy allen, a "farm girl," never moved far from the Bakers Mills area where she was born. As a child she joined the Pentecost Holiness Association, was ordained as a young woman, and has been minister at the Bakers Mills church since the 1940s. "My attendance has never become big except holidays. It's a country church, it stayed a country church and looks like one."

When she was a grandmother, the Reverend Allen was invited to visit the Pentecost Holiness Association in Africa. She was hesitant at first. "A lot of people didn't think a woman could do these things and I didn't think I could. But then I went." While attending a service conducted in Swahili, she noticed a man boring a hole in the ground next to her. "A little later I looked up . . . there was a tree with all the leaves hanging down over me. They had planted a tree right there during the church service among all those people to cover up the one white woman from America and make sure she didn't get sunburned."

Daisy Allen has seen four generations at her country church. "[It's] a very needy area for helping children," she says, and at Christmas she gives a party for the poor children of the area. "Course years ago when we had more productive farms, every farm had its own garden, so the garden was part of the family situation, the children out in the garden." Farms in the Adirondacks are not as productive as they were, and children do not have the same responsibilities. People no longer walk to the same neighborhood church; they drive to the church they choose. Daisy Allen is not unaware of the changes that affect her community and, more subtly, her relationship with her husband Earl, himself a farmer and maple sugar maker. "Earl and I, we do a lot of things together. We've hunted and camped together and I've helped in the sugar camp. I've even helped boil all night, we'd take turns. . . . I've helped him in [the] hay field and sometimes I tell him it's awful hard with church work and farm work together and he doesn't see why, but sometimes I do."

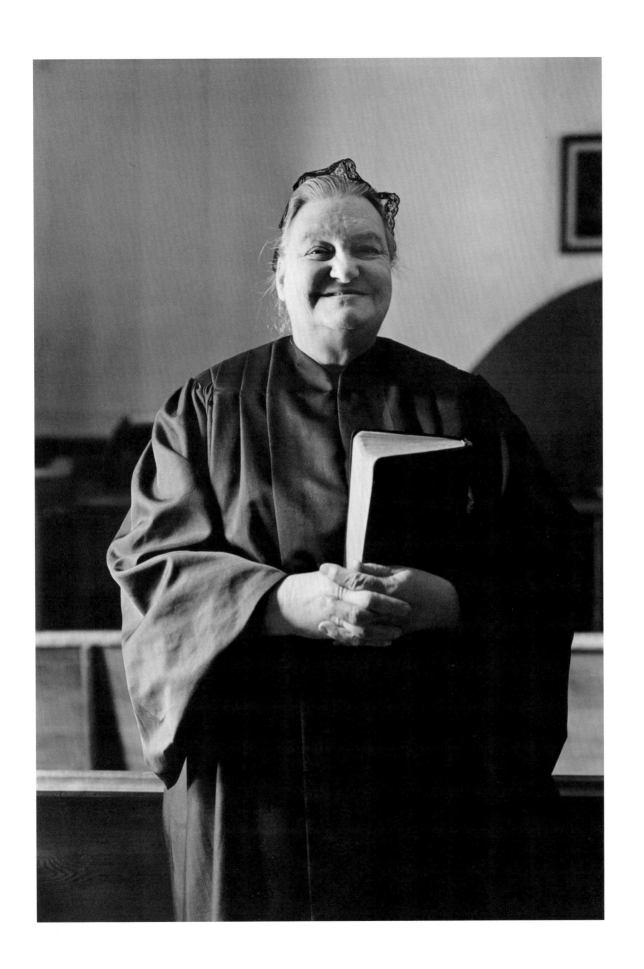

Preacher, 4-H Leader

Bakers Mills, New York

January 1987

EARL L. ALLEN

When he was sixteen, Earl Allen drove the mail stage from Bakers Mills to North Creek, earning twenty-nine dollars a week while he helped run the family farm. Along with farming, the Allens harvested maple syrup and sold cream to a creamery in Buffalo, shipped in five-gallon cans on the North Creek express train. "Some of the old engineers and conductors—I used to sell 'em butter and eggs and things like that." Allen remembers rotating the old coal-fired steam engine, whose terminus was North Creek. "They'd just back it onto this turntable and we'd push it around by hand. Afterwards they put an electric motor on it."

Earl Allen is "the third generation of Allens that's made hay rakes. We make 'em out of all hardwood. The teeth are ironwood or hardhack, and the rest of the rake—the bows, the heads, and the stales—are made out of white ash. This here is for hay. A metal rake doesn't work good on hay. But you can use this on leaves, things like that, in the ground and around lawns." Allen claims no one else is making wooden hay rakes today, although he's teaching his grandson to make them.

"I'm the only one in this particular area that moves hunting parties back in," says Allen, referring to the Siamese Ponds Wilderness area, where motorized vehicles are not allowed. The hunting party walks in eight miles while Allen makes two or three round trips hauling in supplies with his team and wagon. He believes that coyotes have hurt the deer population. "They follow the doe just before she has her little one, then eats the baby. Kills it. We've listened to 'em many a night when we lay there in the tent, and you'll hear one and in a little ways there'll be another one hollerin' and there's usually three. Three coyotes will kill a deer. [Now] they've passed a law on coyotes; you can't kill 'em any time of the year. Where there was one time, there was a twenty-five dollar bounty on them. Now they got it back the other way around."

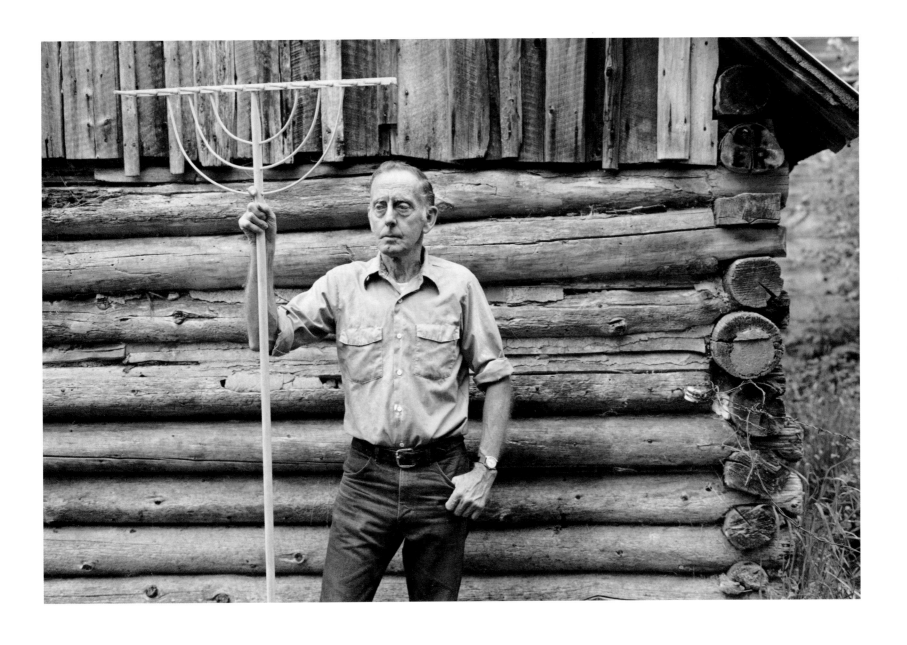

Wooden Rake Maker, Teamer,

Farmer, Maple Syrup Maker

Bakers Mills, New York

June 1987

DEBBY BOYCE

Debby boyce started chopping and cutting at college. "It got me hooked [and] I started competing. I didn't know what forestry was when I went to school," she admits, "but I just stepped boldly into it and found out I liked it."

Boyce works as a forest technician for Peterson Forestry, Inc., in Wilmington, New York. Her work includes managing grass habitat as well as forest, marking boundaries, and doing timber inventories. "It all depends on how much [the client] wants to cut. We go in and take the diseased trees first, and then we take the trees that are past maturity. We try to leave the good quality stand of timber last so that they can come in every ten to twenty years and take out nice trees. If the trees aren't cut then, the growth starts stagnating. It's better to cut a few out and you get the fullest growth you can out of your forest."

Boyce and her husband, also a forester, like to camp, hike, and hunt with bows and arrows as well as compete in chopping contests. Although she worked for the Forest Service in Montana, she'd like to stay in the Adirondacks. "I love the mountains," she says.

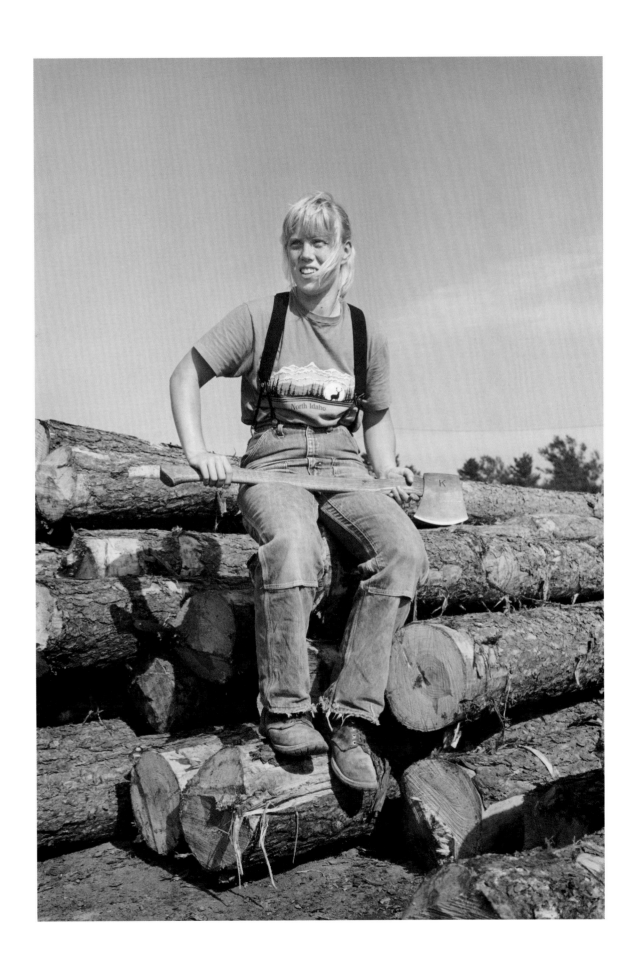

Forest Technician,

Chopping Competitor

Jay, New York

August 1987

ROBERT E. BROWN

A "TRANSPLANT" from western New York, Robert E. Brown came to the Adirondacks twenty years ago because "civilization" was encroaching on his hunting grounds. "I'm a hunter and fisherman as my avocation," says Brown, "and as my vocation I'm a sociology and anthropology instructor at North Country Community College. Lot of times when I'm grading papers I hand [them] back [and] the students want to know why there's a dog print across the paper . . . and I tell 'em 'cause I'm grading 'em while I'm sittin' out in the woods hunting. That's when I'm in a good mood.

"Hunting for me is probably the greatest gift my father ever gave me. I like to hunt a variety of game. And I like to pay my way. And part of paying your way is getting involved with the animals."

Brown calls himself a conservationist, rather than a preservationist. "I believe in wise use without misuse. I believe in wildlife management techniques. I like the traditional ways of hunting. I use traditional firearms, I don't own a snowmobile, I don't own a four-wheel drive, I hike most of the places I go. . . . There's a difference between killing and hunting," he continues. "To me, to be able to get the ducks to cup over my decoys and see 'em land . . . you don't necessarily have to kill the game all the time. I like being out there."

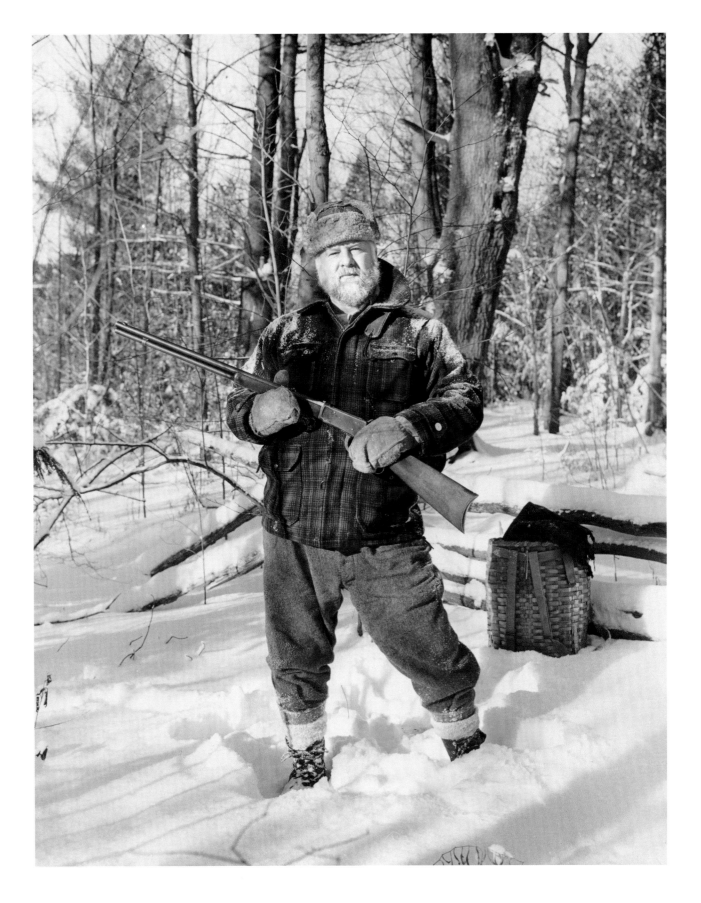

College Instructor,

Hunter, Fisherman

Saranac Lake, New York

December 1986

FREDOLIN BURKE

FRED BURKE of "Burketown," Raquette Lake, runs a boat livery and trailer park, rents cottages, does carpentry, and at one time sold real estate and was in the sand and gravel business. There's always something to be done, according to Burke, even during the off-season. He feels his business is being squeezed by a shortened tourist season, for which he blames the schools and the state. "State Regents, they give 'em too much vacation during the year, and stretch the school year up to the first of July," he says. Tourists are encouraged to leave the area in September when nearby campsites close. "State's been closing up [campsites] Labor Day the last four or five years here. We lost all our customers. Old-timers would come up in September and October."

Winter brings diversion if not profit to Burke. He's a good fisherman—for cars in Raquette Lake that drop through the ice. You can still get them going again after a couple of months, he says, although the upholstery is "pretty soggy stuff. And the engine you've got to tear all apart. Soon as you pull it out of the water you got to tear it apart right then, you can't wait. Or it'll rust. It's under water, it can't rust."

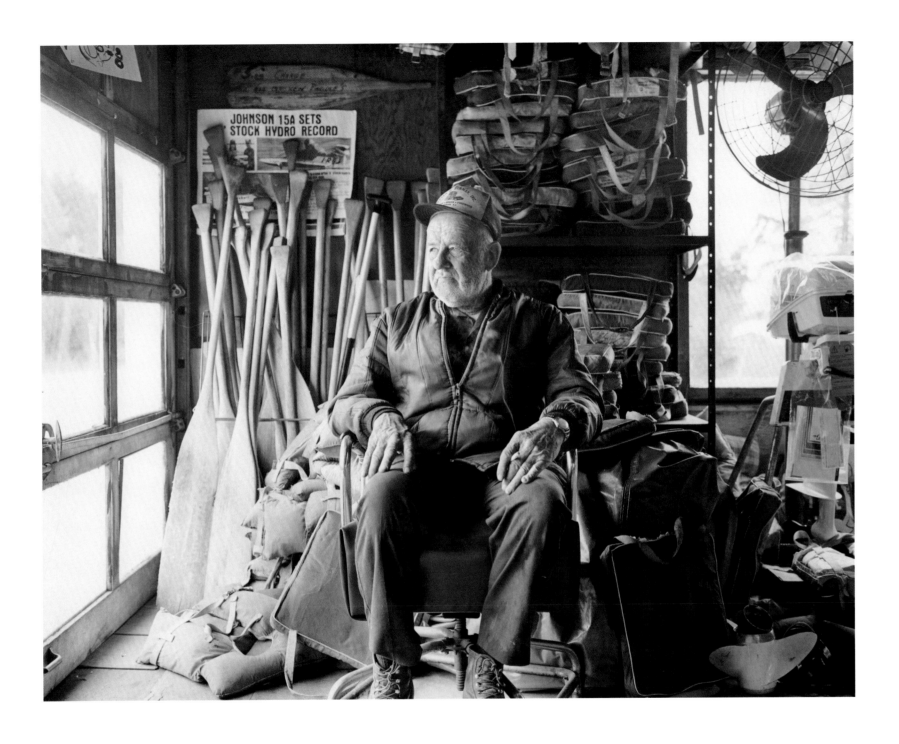

Owner/Operator Boat Livery

and Cottages, Carpenter

Raquette Lake, New York

September 1986

JIM CAMERON

Jim Cameron's first acquaintance with guideboats was in the summer when he came to visit his grandparents in their Adirondack camp on St. Regis Lake. In 1980, Cameron moved from Wyoming to live full-time in the Adirondacks. He studied boat building with Ralph Morrow and Saranac Lake's Carl Hathaway, well known in the region for his guideboats.

Today's recreational guideboat takes Cameron about three hundred hours to build and is lighter and narrower than traditional guideboats, which were often used for freight and could support up to twelve hundred pounds. "They were designed to carry two men and all their gear and a deer. [They were] light enough to carry around. Guideboats sort of blasted the Adirondacks like covered wagons, you know, in the West. Because it was so wooded here that the best way to get around was through the lakes. They were the boats that forged the way.

"The ultimate in woodworking is guideboats," says Cameron. "The advantage to guideboats is that I can go out in the backyard here and cut all the materials. So for the price of the chinks, I guess, I can get the wood. If I'm dealing with walnut, mahogany, all this fancy stuff, I've got to go to who knows where, Poughkeepsie, or somewhere, to get it."

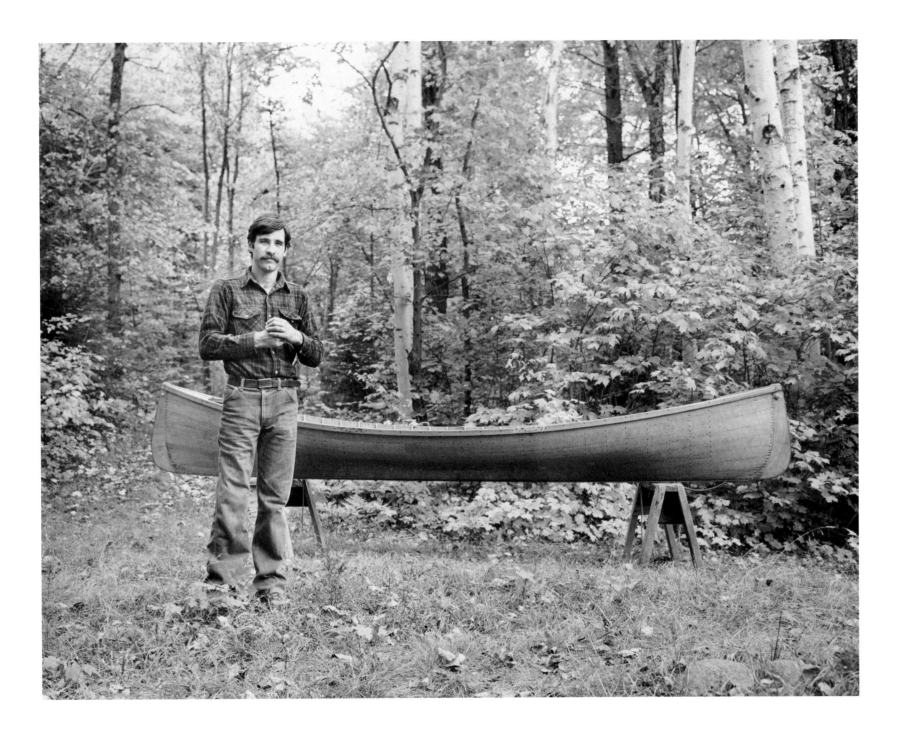

Guideboat Maker

Upper St. Regis, New York

December 1986

JUDY MANCUSO CONVERSANO

LONG ISLANDER Judy Conversano, born in New York City and raised in Cuba, weekends in a year-round vacation house near Old Forge with her husband, Dick. "We usually come up like every Friday night. We always bring friends up. And we go riding. You ride like about half an hour to an hour, you stop at one pub, relax, have a cup of coffee or hot chocolate and have a few drinks, popcorn. Then you go back and get dressed up and you go to the next pub. That's done in order to keep warm. . . . Half the time we're riding and we see a deer or two deers eating and we'll take pictures."

The Conversanos, who own six Yamahas, travel up to two thousand miles per season on trails around Old Forge, "the capital of snowmobilers. . . . It's so beautiful and peaceful up here," says Judy, "like another world. Everybody's so down to earth and friendly." Of the local business people, she says, "They cater to us, even though they're making the money. But I feel a resentment because they can't, I don't know, afford the machines or they just don't like outsiders. All the snowmobilers are practically all outsiders, they're not really from the area. Very few you will find people from the area that want to go snowmobiling. They don't have the time to do it. . . . You want to have a little fun and enjoy your life a little bit," she continues. "You work hard and then you start seeing things differently, you want to enjoy yourself.

". . . It's basically really really nice up here. Very peaceful. And that's what we need when we're from downstate; our life is very hectic down there. When you go down to the city nobody'll know who you are. You're just a dollar sign. Here they know you, 'Hi Judy, Hi Dick.' . . . And you feel comfortable and you bring your friends and that's how it is up here. This is a little touch of friendliness."

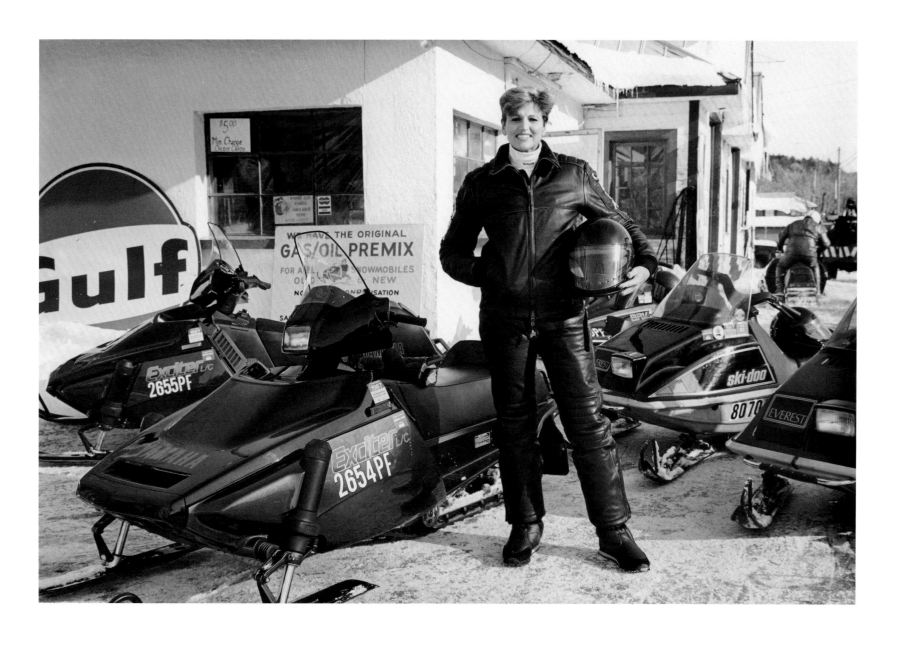

Hair Stylist, Snowmobiler

Old Forge, New York

January 1987

MICHAEL CORSALE

CALIFORNIAN Michael Corsale, while visiting his cousin in Glen Falls in 1983, bought his North Creek property at auction for six hundred dollars, sight unseen. "So I came here and I love it 'cause it's beautiful, you know, every time you blink an eye you're looking at beauty. . . . The people around here, that's why I stay to be very honest with you. I had a Volkswagen that I drove in town here. I broke down and two days later the guy that gave me a ride home showed up at my house with a bag of groceries and his tools. He says, 'Let's fix your car.' "

Corsale, whose father was for thirty-five years a chef on the tuna boat *S.S. Starkist,* "grew up in the restaurant business. My father's ancestors used to cook for the king of Italy centuries ago." Corsale says he works sixteen hours a day for six days a week. "I'm trying to create more jobs here. And I want to sculpt. A friend of mine brought me a big chunk of red oak. It's got nice grain and it cuts good if you use sharp blades. It's being preserved, underneath my mobile home, not getting wet or anything."

Tourists attracted by the Gore Mountain ski area, a state-run facility, and rafting companies running the Hudson in the spring have helped his business tremendously, says Corsale. "But above that, way above that, the local people are my business. If it wasn't for the local people, they support me, I lean over backwards for 'em. You get in trouble around here, one person will know you, he'll bring ten other people to help. Snap of a finger. I mean that, I've never experienced anything like this in my life. It's not my place, it's their place."

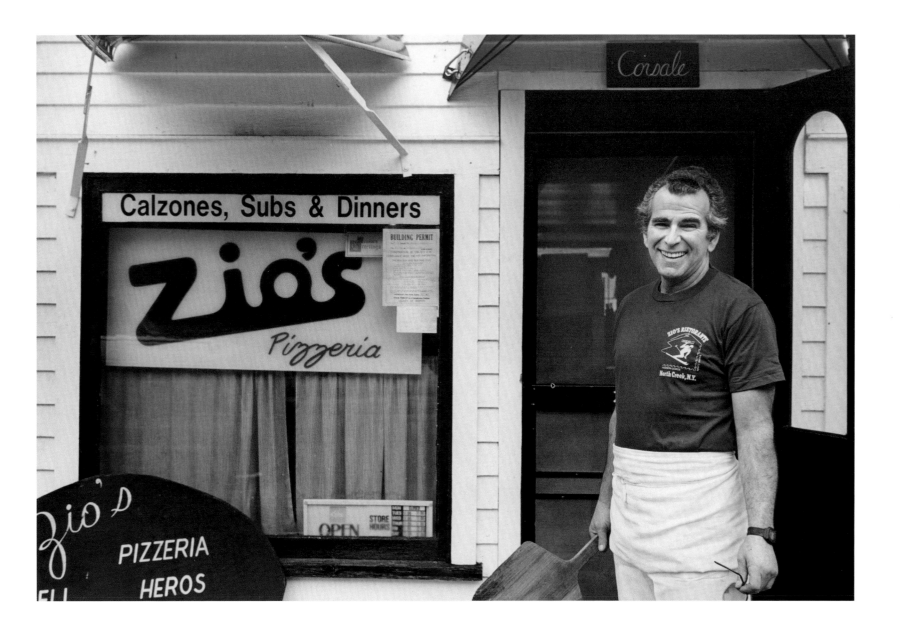

Pizza Parlor Owner and Chef, Trucker

North Creek, New York

January 1987

KATIE CROSS

KATIE CROSS is a fifth-generation Adirondacker. She learned "buff knitting" (in which the yarn is looped between stitches and then cut to create a thick pile) from her mother, who made and sold mittens to the lumber camps. Katie Cross sells mittens and slippers all over the country, taking orders from as far away as Alaska. People don't wear them much for work anymore, she claims. "Mostly they wear 'em, you know, just for comfort. They wear 'em for bedroom slippers . . . and fishing, too. I just knit the long ones like these . . . they put boots over 'em."

She believes she's the only one left in the Adirondacks who does buff knitting on a regular basis. "Always knitting. Knit evenings and sew days." Katie can knit and watch television. Her mother, who didn't have television, "could knit and read. I've seen her knit and read."

When her house burned, neighbors built her a new one, complete with garden. "They worked weekends. And the women brought food on weekends, and they'd be anywheres from two or three to twenty-some here workin'. Women pitched right in, too. Us women insulated it right along with the rest. They put in the garden, kept the lawn mowed and everything—they furnished it. I wouldn't live anywhere else," she says.

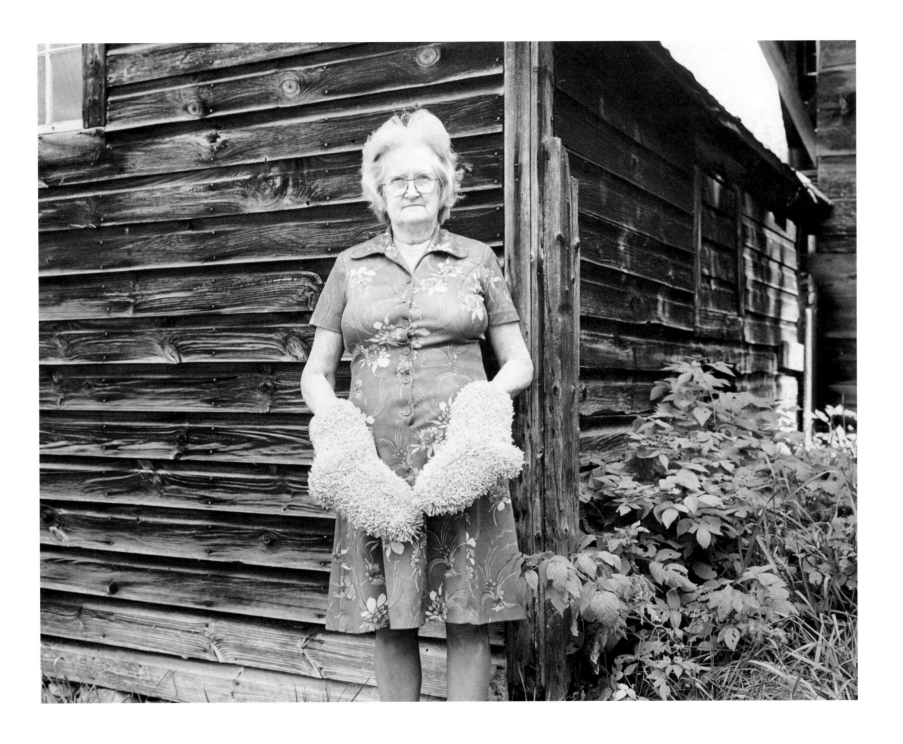

Knitter

Johnsburg, New York

September 1986

MAITLAND G. DESORMO

Maitland desormo, born just outside the Blue Line in Canton, New York, has given nearly four hundred slide lectures and written nine books on aspects of Adirondack history and on Adirondack personages, including hermit Noah John Rondeau and photographer Seneca Ray Stoddard. "He wasn't as much of a hermit," DeSormo says of Rondeau, "as a lot of people were led to believe. His little village of teepees and town hall was just twenty yards or so off the [Northville-Placid] trail. He had plenty of company all summer. Everybody loves a hermit, especially when they become professional hermits like Rondeau."

DeSormo tells this story about Rondeau's diary. "The old boy had what he called his secret script. The thing had to be read in concentric circles. It was in concentric circles, and you read from the outer circle in." A reporter who knew about the diary asked Rondeau what he'd written. "You know, the old son-of-a-gun couldn't read it himself. He'd come up with it, conceived the idea a long time before, and lost the key to the hieroglyphics himself. Some of them were Indian signs, and some were signs of the zodiac. The old boy was a pretty good amateur astronomer, you see—not astrology, but astronomy.

"My real hero was Stoddard, though. He's the one that made it possible for me to have an interesting and fairly productive retirement because his photographs gave me all the illustrations I needed for about five books."

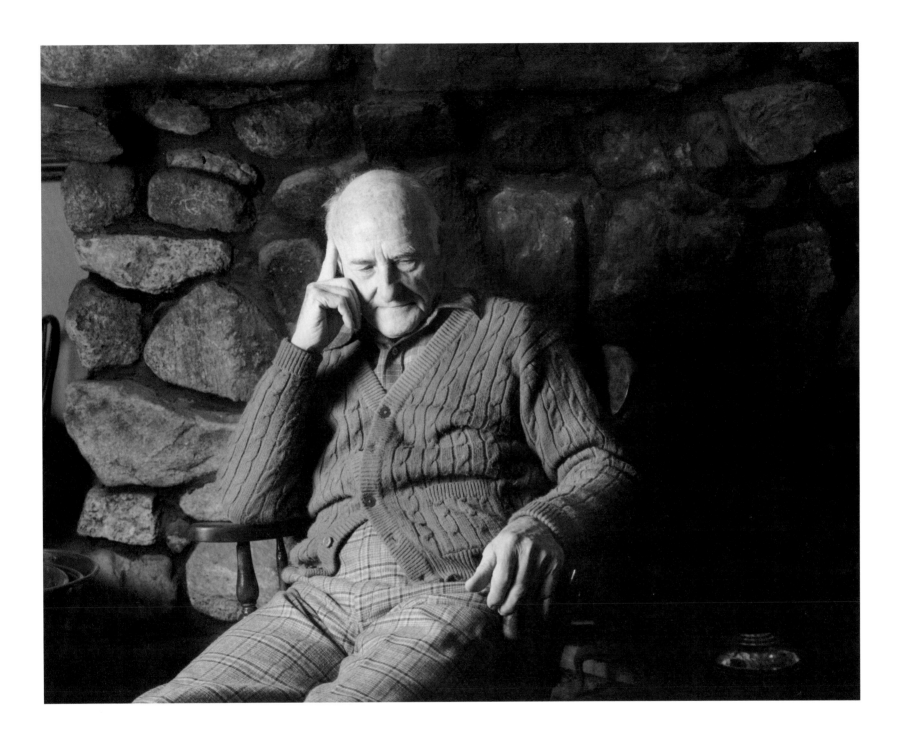

Teacher, Lecturer, Author

Saranac Lake, New York

October 1986

PAUL DICOB

Paul dicob, fifth-generation lumberman, has worked the Adirondack woods with horses since age fifteen. "I love the big Belgium horse," he says. "These people that want to have their forest—something left—why they'd rather have horses come in because a horse can sneak through the trees where these big machinery can't get through. And you're not markin' the forest all up. Another advantage about the horse—you cut your logs about sixteen foot, fourteen foot, and skid 'em log like. Where these skidders, they go in and skid 'em tree length, and then when they make a turn in the woods they sweep everythin' sideways."

Horses still have their place in the woods as well as machinery, Dicob maintains. They're a lot less dangerous than a skidder. "You holler whoa and they stop. Where a skidder, you could holler all day and they could kill ya, they keep right on going.

"I think after the woman, the horse is next. They're just a natural if you treat them good." Dicob is pleased that he operates his logging operation much in the same way as did his father and grandfather. "Then my son, he's pickin it up," he says. "So I'm sure someday he's gonna be into it also. He really enjoys horses."

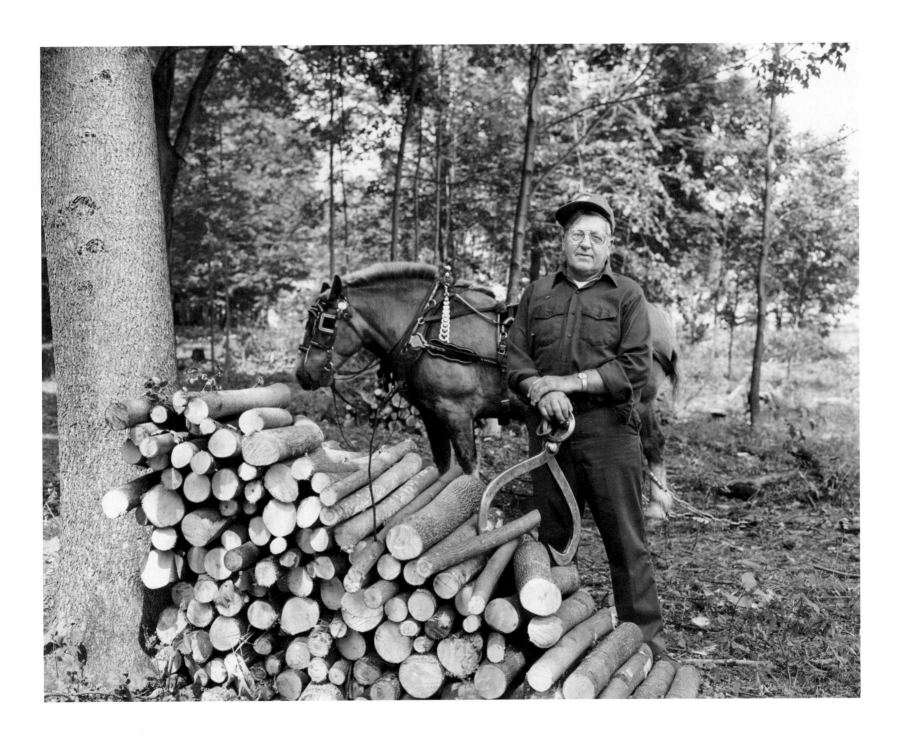

Logger

Lowville, New York

August 1987

ADRIAN EDMONDS

ADRIAN EDMONDS'S great-great-grandfather built a log cabin in Keene following the Revolutionary War, before the township was formed. A carpenter and home builder by profession, and a forester by inclination, Edmonds believed as early as the 1930s "that the aesthetic value of the forest would be far more in the future than the commercial value at that time. . . . In the lands I bought, I tried to remove the diseased trees and the inferior species and give the goodness of the sunshine and soil to the more hardy trees."

Edmonds's grandfather, the youngest of ten children, was bonded as a manservant to a family in Keene Valley until he was twenty-one. "I had the good fortune to be apprenticed to my father, who was an excellent carpenter," says Edmonds, who began work in the valley in the 1930s, repairing buildings and modernizing interiors. "It was easy for me to visualize and draw plans." He thinks that the school system has not gone far enough in preparing students to earn a livelihood in the Adirondacks. "I wish that students from local schools could work with the older men who are the tradesmen of the various areas wherein they live."

Edmonds's primary objective over the years has been to attract nonresident landowners, whom he believes reinforce the life and economy of the region. "In the lands which I've purchased, I've walked them for hours and hours in an effort to find the promontories from which exceptional mountain views would be available. And after I had identified these places in my mind and in my ownership I undertook to build a road system that would serve those promontories. As a result of those endeavors, we have brought in many families of good standing. These people [are] highly sensitive to the natural beauty of the Adirondacks. They value the isolation and the privacy.

"We do have an unspoiled community," he adds. "Those early owners purchased a lot of land along the main highway and would not sell it. And that has prevented unsightly and small commercial enterprises from springing up along the main road in contrast to what you find in other Adirondack towns. That is nothing that the native did. That was something that the nonresident owner did. And it is paying off in our community today."

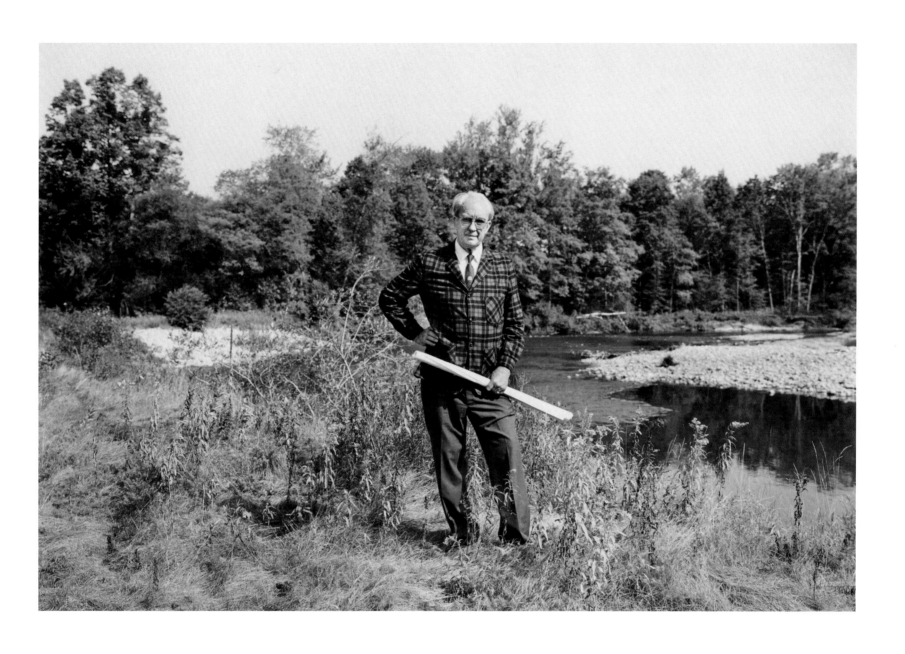

Carpenter, Town Board Member,

Road Builder, Home Builder

Keene Valley, New York

August 1987

NATHAN FARB

WELL, I DO GET VERY EXCITED when I'm out there in nature. I jump up and down and yell, I act like a child essentially. . . . I feel wonderful," exclaims photographer Nathan Farb, who grew up in the Adirondacks, left the region, and returned. "I don't think I came back as a landscape photographer," he says. "I came back knowing this is one of the most beautiful places there is. I felt this place had never been really photographed. You know, had never been shown for what it is. I felt like I had a mission.

"Often I find a place where I feel certain powerful physical forces. Sometimes you can see those forces with the lines that ice has scraped across the rocks. Sometimes you can see very clearly what the wind is doing to the trees on mountain tops. There are visual manifestations of the natural forces. And a lot of times that's what I'm trying to photograph."

Another important aspect to his work is detail, according to Farb. "Photographing the little water grasses there speaks about the flow of the river and the sunlight that makes them grow in a certain way. Detail is one of the most important things you can present to people. That's where reality is. It's really one of photography's great strengths . . . it can deal with the exactness of things so well."

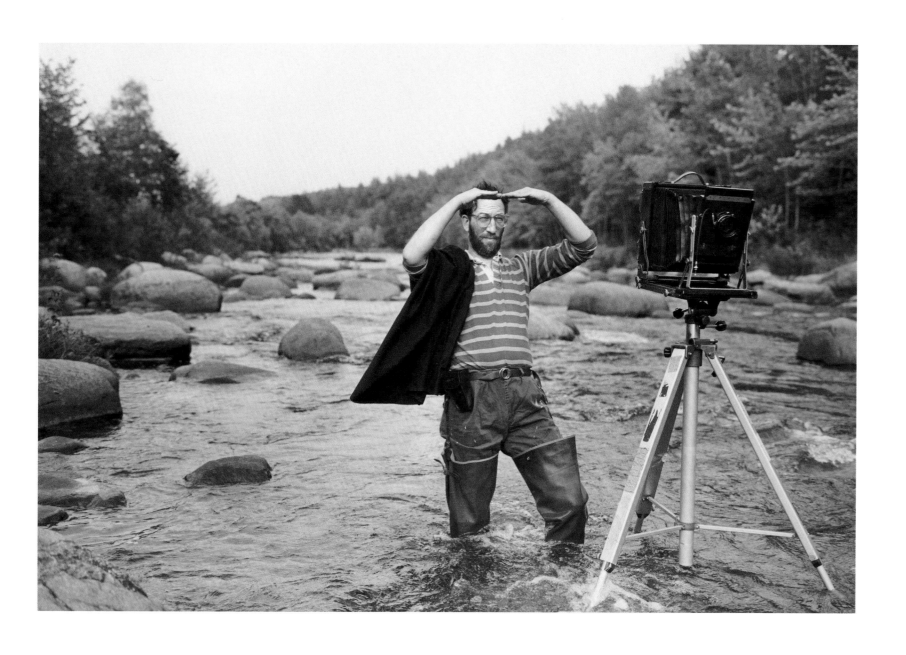

Photographer

Keene, New York

August 1987

GREGORY AND CATHERINE FARRELL

THE FARRELLS, who work in New York City, bought the land near the stream where they used to camp. They built their round house, a yurt, in 1976 in ten days, assisted by one chain saw and numerous friends. "We had worn some of our friendships almost out at the end of that time. We'd never built anything more complicated than a birdhouse before. So it was a grand adventure. Like a barn raising."

The Farrells contrast their life in Keene with the high pressure of life in New York City. Their yurt has no electricity or running water. "We don't have a telephone, and the pace of human connection here is much more leisurely and much more humane. It's a great place for our boys to learn things. The first time each boy was here they immediately headed into the stream to get wet six or seven times a day, get their footing, catch fish, catch water bugs, catch frogs, gather wood."

Living in a circle, say the Farrells, is economical and unobtrusive. "You don't spend your day inside. [A yurt] throws you into the outdoors. We don't cook fancy things much. But we cook them all virtually on an outdoor fire. This [yurt] is sort of like a cave that you crawl into to sleep and maybe read and all the rest of it."

Greg, whose friends show up without calling to sleep in the round, would sometime like to build what he calls a beaver yurt. "Which would be a yurt you would put out in a pond and you would have to enter through the water from underneath . . . you'd have to swim in. And make sure that all your friends were clean by the time they got there."

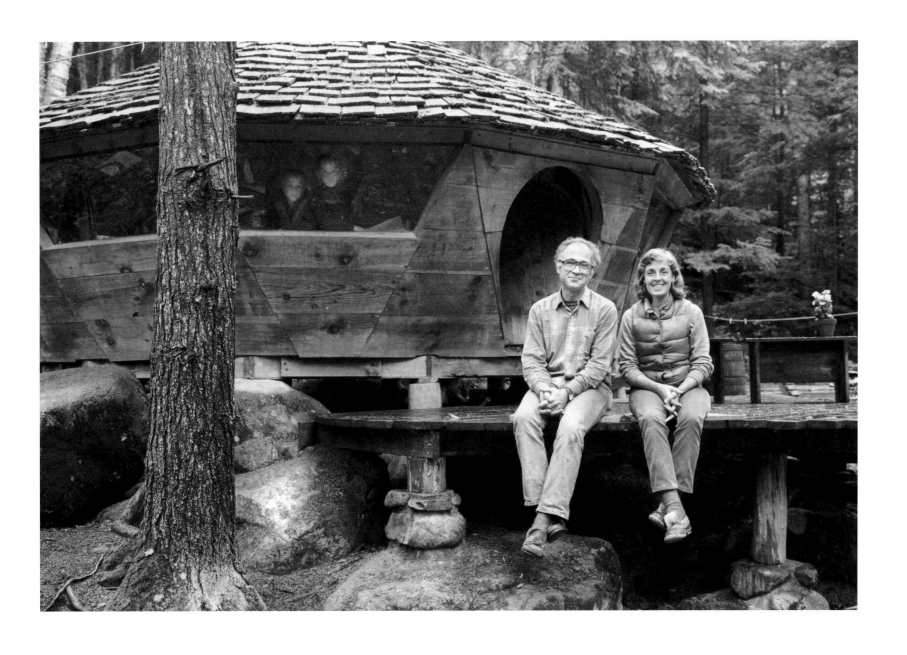

Executive Director, Fund for the

City of New York; Yurt Builders

Keene, New York

August 1987

HAMILTON FERRY

Ham ferry's grandfather, a guide and a trapper, came to the Adirondacks from Vermont; his father drove logs on the Raquette River for sixteen years. After attending college in Cincinnati, Ham worked for Yellow Cab in New York City, followed by a stint as an officer in the Salvation Army. He returned to the Adirondacks, where he became a guide for hunters on land he leased from the Raquette River Paper Company. In the early 1950s, when they built the dams on the Raquette, he opened his bar and inn at Sevey's Corners in the house he'd built in 1933.

Ferry has been reciting poetry "ever since I was a kid." Many poems he learned from his grandmother; others he picked up by reading poets such as Robert Service, "my big one." He recorded forty-seven poems on tape for New York State, and he still recites at festivals and gatherings throughout the North Country, although he complains it's harder for him to memorize. "Use to be, if I wanted to learn a poem and I liked it, I read it over once, then I read it the next time and that was it."

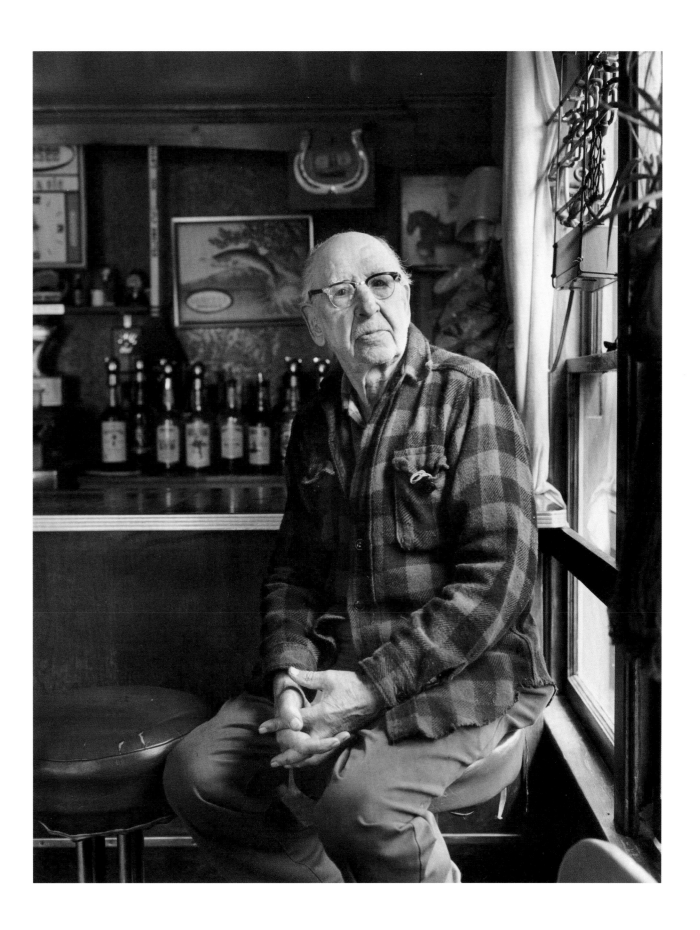

Innkeeper,

Reciter of Poetry,

Former Guide

Childwold, New York

August 1987

ERNEST FLANDERS

Eʀɴɪᴇ ꜰʟᴀɴᴅᴇʀs came to the Adirondacks in 1921 "when the forge jobs was here." Former mining towns were turning to an alternative means of support, such as tourism, by the first quarter of the century. Flanders has always lived alone, and supported himself cutting wood and ice until the 1950s, when people began to buy electric refrigerators. He recalls the 1930s: "We pretty near starved to death, you had to eat frozen potatoes, bake 'em in the oven and eat 'em. That's all we had one winter here. That's in the Depression. . . . There was no work of any kind.

"When I started cutting wood, I wasn't any good at it to start with. . . . I used to sell a lot, but I'm getting so I can't split it. I got one arm cut twice in the same place. With the same saw."

Flanders grows his own vegetables but has never canned anything for the winter. "Now they bring Meals-on-Wheels . . . some is good, some is terrible. They cook it down in Forestport and Boonville. Five days a week they bring 'em." He says he has trouble breathing the cold air. "I don't got no records, no TV. I read a lot of magazines. I get more magazines than I know what to do with."

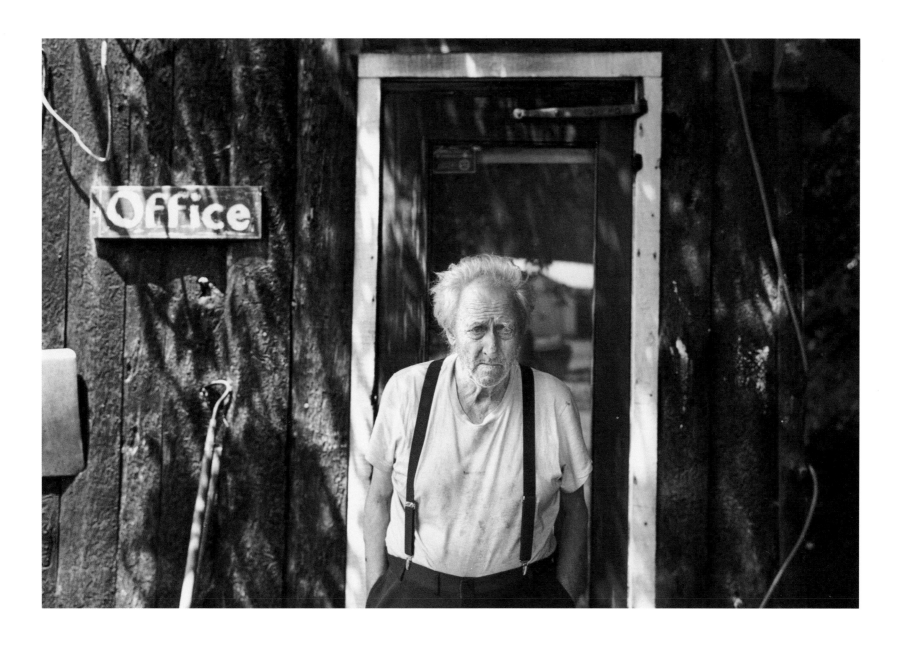

Firewood Dealer

Old Forge, New York

June 1987

GEORGE FOUNTAIN

When he started logging, George Fountain had anywhere from ten to twenty horses. "We cut pulp through the summer. There was some of the years that we had to peel the pulp before the mills would take it. And then we'd put it up in the fall after the peelin' season was over. We'd skid it up on skids and cut it up and pile it. And then in the wintertime we'd take it to the mills. And then later years we used a tractor to skid and then put it up in yards and hauled it with trucks to the mills. And then I went to a skidder, and we did that with a skidder. We'd haul it. The skiddin' got longer then, longer ways to skid.

"Horses went out, on account of the timber got more scattered and it would take a lot longer to put up a cord of wood. You skid with a horse maybe a thousand feet or so—a half mile is nothing for a skidder, you know. . . . In 1945 we put up two-and-a-half million feet of first growth pine with four pair of horses. And we skidded it to truck roads that we built in the woods with a tractor. Then we hauled it to the mill with trucks."

Fountain uses his horses today for the state "to haul supplies into the wilderness areas. Trucks are not supposed to be in there. What I use the horse for is to truck in supplies to the ranger stations and for the bridges and the lean-tos. The ranger lives right in the stations, and we take in wood and bottled gas and supplies for the cabin. We're in the woods about ten to twelve hours from the time we leave until we get back [to the trailhead].

"There's quite a few people using horses to get up stove wood," Fountain continues. "Because the price of equipment now has got so high, they're gradually going back to using horses some. Your average skidder costs about seventy-five thousand dollars. A good horse'll cost you around a thousand dollars."

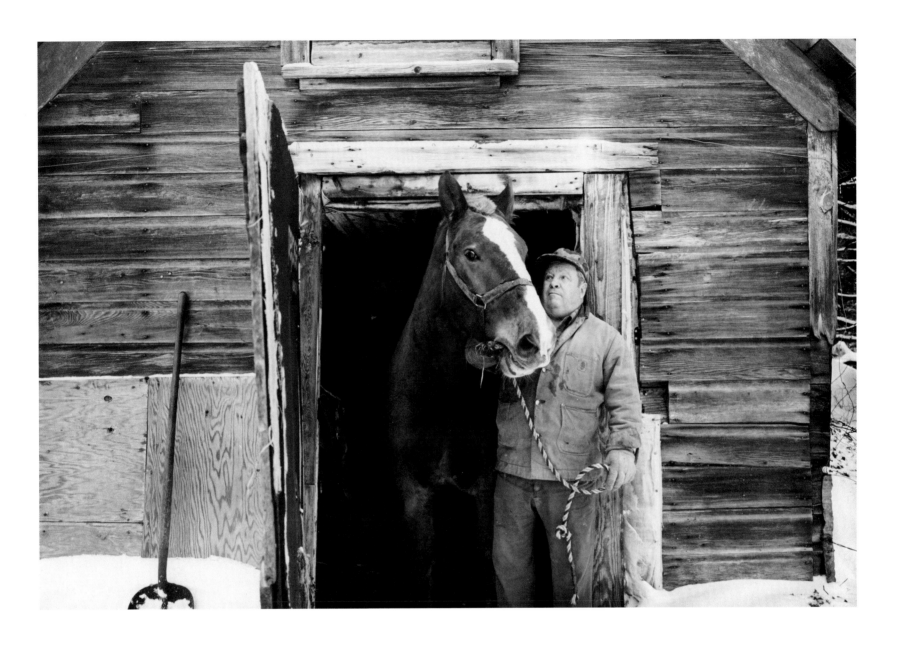

Logger, Supervisor

Meecham Lake Campsite

Paul Smiths, New York

December 1986

ARTHUR GATES

FOURTH-GENERATION Adirondacker Art Gates competed in a guideboat race at age seventy-seven. Guideboats were "a way of transportation," according to Gates. "There was camps around the lake, and the only way you could get to them was by boats. And, of course, in the winter you could go on the ice."

The ice also served as a road for loggers. "They used to work horses on the lake," says Gates. "Had to haul logs across Blue Mountain Lake and then put 'em on down to Lake Durant. And it wasn't so uncommon to see horses be overloaded, ice'd be weak . . . they'd break through. They had a rope on the draw boat so the minute they started breaking you'd yank the draw boat out so the whipple trees and neck yokes would be free of the sleighs, the sleighs would go down but the neck yoke [would] stay with the horses . . . and if there were two or three men around it wasn't too awful hard to get a horse out of the water, especially if they cooperated with you. [You'd] let the load go to hell. And then of course later you could retrieve it.

"There was a lot of livery stables around then, because people hired horses to take them from one place to another. So there was always transportation, and if you didn't have the money you walked. It wasn't nothing in those times for a man to walk from here to Indian Lake, twelve miles. I walked one time from Speculator right through here, forty-two miles."

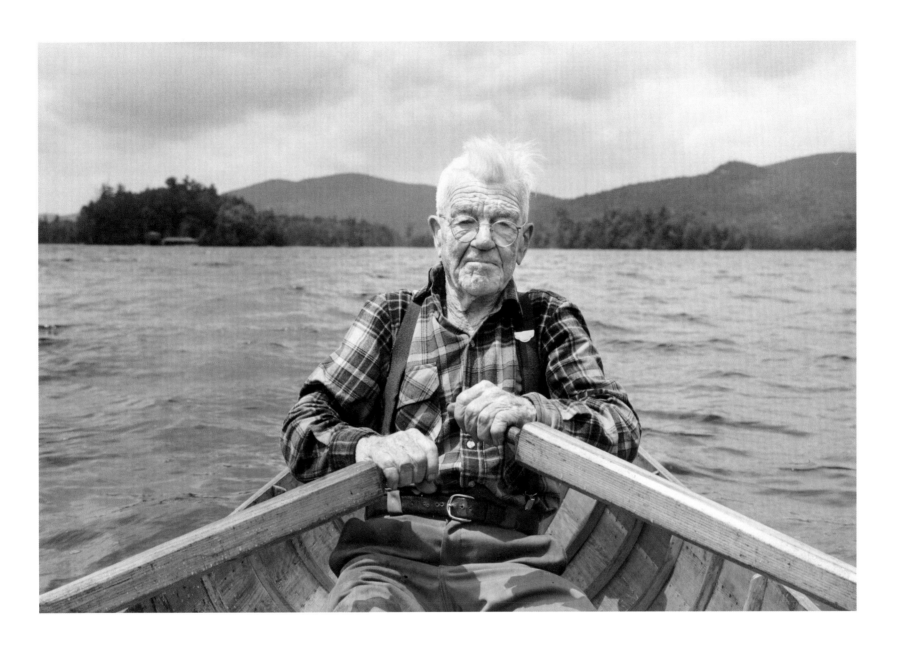

Guide, Lumberman, Caretaker,

Carpenter, Guideboat Competitor

Blue Mountain Lake, New York

June 1987

BEECHER G. HARVEY

Born and raised in the Adirondacks, Beecher Harvey and his three brothers grew up on his father's ten-acre "soot soil" farm. "On the sootiest soil he'd grow buckwheat; he used to send that to the mill to have made into flour. I don't believe there was a morning my mother didn't make probably fifty to sixty pancakes when us boys was growing up. We had lots of potatoes. My father'd put about fifty to sixty bushel in the cellar. My mother would peel approximately a peck of potatoes to a meal. . . . My folks were close to the earth. We had johnny cake, fried pork, and such stuff as that, which people don't even eat today.

"For the last twenty years I've [been] on this one farm. [When] I started out here, the land was run out. Manuring it and working on it, we got it to where it cut better than six hundred bales of hay this year, plus we raise our gardens and it's a relaxing place. My father before me, he was a farmer, and he always told me in order to take out of the land you have to put back into it.

"There's a lot of work to farming," Harvey continues, "but there's no young people that's even attempting—now this place here, in the condition it's in today—I couldn't get a young one to come in and take over. They just don't want that much work. All the farms in the country, the city people come in and buy 'em up. First thing you know, you got a crop of young scrub trees growin' up."

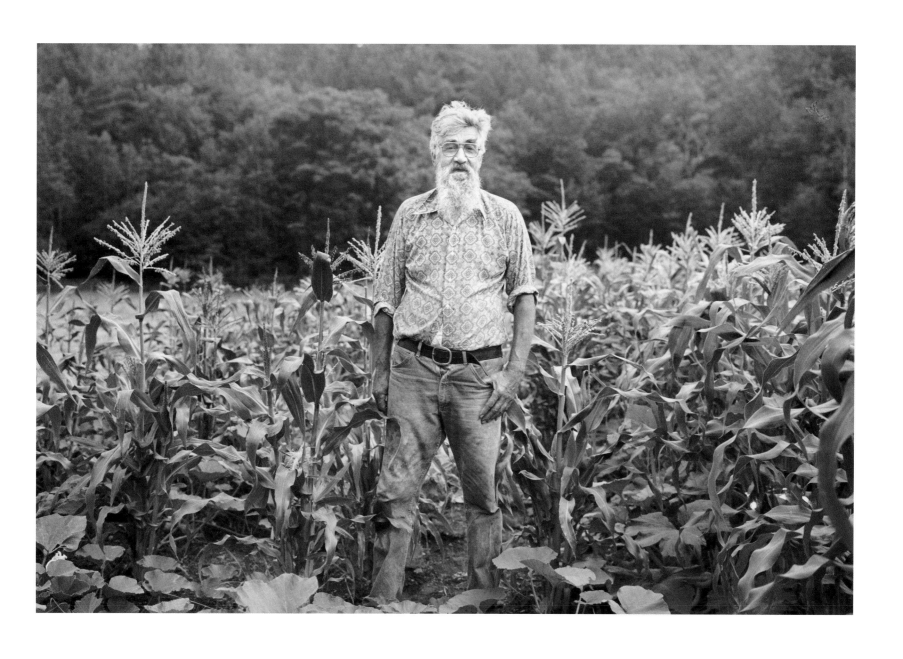

Lumberjack, Farmer, Carpenter

Warrensburg, New York

August 1987

JOSEPH TENDERFOOT HILL

I WAS ALWAYS a man of the woods and of nature," claims Joseph Tenderfoot Hill, who remembers taking a boat to the schoolhouse across Raquette Lake where he lived when he was small. "I believe that if people love nature they will love the human being. I don't see colors of a person, but I look at them all as human beings. . . . Many times I go out looking for people that are lost. Since I've been back in this part of the woods living at Woodgate, I have found four people so far.

"My name in Indian is Lo-Shee-Dan-Hiska, which would mean 'Soft Foot.' Whenever I hear someone say, well, what tribe you're from, the first picture that comes into my mind is a savage. I happen to be from a sovereign nation. I believe that everybody, no matter what nationality they may be, should be very proud of what they are."

A skilled hunter and fisherman, Hill studies where the animals go in the summer and returns to those spots to hunt them in the winter. He does not smoke or eat while he hunts. He steams the fish he catches in a piece of driftwood or bark stuck together with spruce gum, and when he beds down in the woods on pine boughs, he circles himself with a rope "to keep the crawling creatures away because they don't seem to crawl over the rope when they come near it.

"It's a great life, I don't regret my life," he says. "I'm great for medicines, I've had people come to me that are Indian people and that had sickness . . . of course we're great for herbs. I believe in having the full strength of the herbs and the medicines that the Creator gave us."

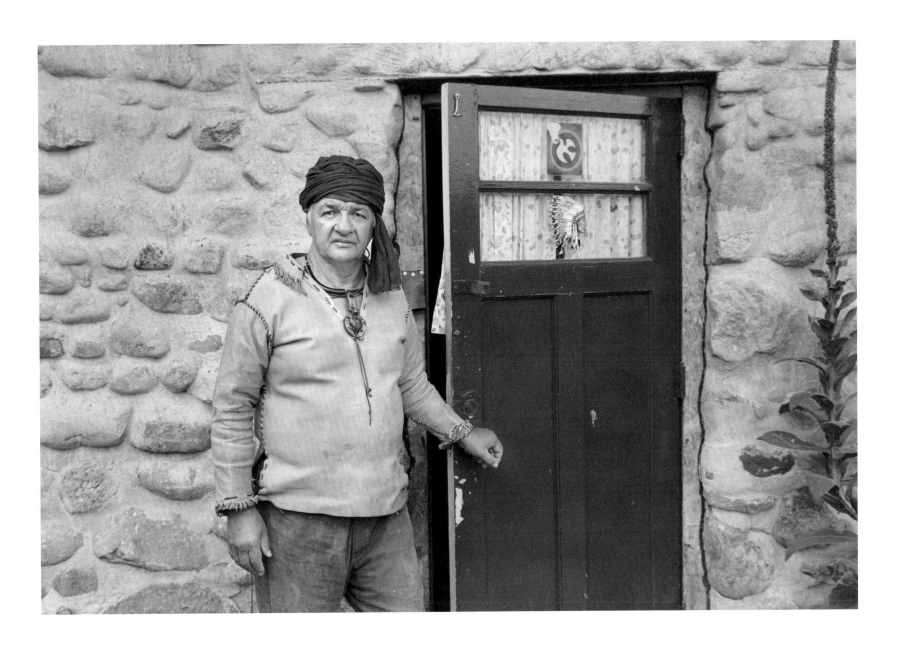

Artist, Sculptor,

Spiritual Teacher, Woodsman

Woodgate, New York

August 1987

GARY HODGSON

Member of the twelve-man New York State Helicopter Rescue Team, the "hard team," Ranger Gary Hodgson is involved in about two hundred search-and-rescue missions a year. When he arrived in the area in 1965, there were only a few. "But around the seventies," he notes, "when the big back-to-nature phase hit, [there] was a dramatic increase." People get in trouble more in rainy weather than when the sun shines because "their mental attitude changes," says Hodgson. "Their whole spirit drops, and I think their awareness drops, which contributes to an increase in accidents." Most rock-climbing accidents don't turn out very well, he admits. "The sudden stop at the bottom's what, quite often, does it."

The ranger in whose district a person is lost becomes the director of the search. Hodgson says one of the director's hardest tasks is to convince his search team that the person they're looking for "has a chance of bein' alive. When they really think a person's alive [they'll] put out much more effort. The human body is tougher than most people think. Even the individual themselves. Very, very few have we ever had that we did not find alive."

Hodgson, who feels out of place in a city, is comfortable in the woods by himself. If he's not hunting for people, he hunts deer in "the primitive manner," with a muzzle loader. He believes his skill in woods lore is a gift, and he's fortunate to have a job he likes, but, he adds, "I explain to [people] you have to enjoy it when it's thirty below zero, you have to enjoy it when it's pouring rain. . . . The ranger job is kind of a jack-of-all-trades job because you could be on a search or rescue, you could be fixin' a phone line into an interior cabin or fire tower. You could be fighting a fire, you could be giving a talk."

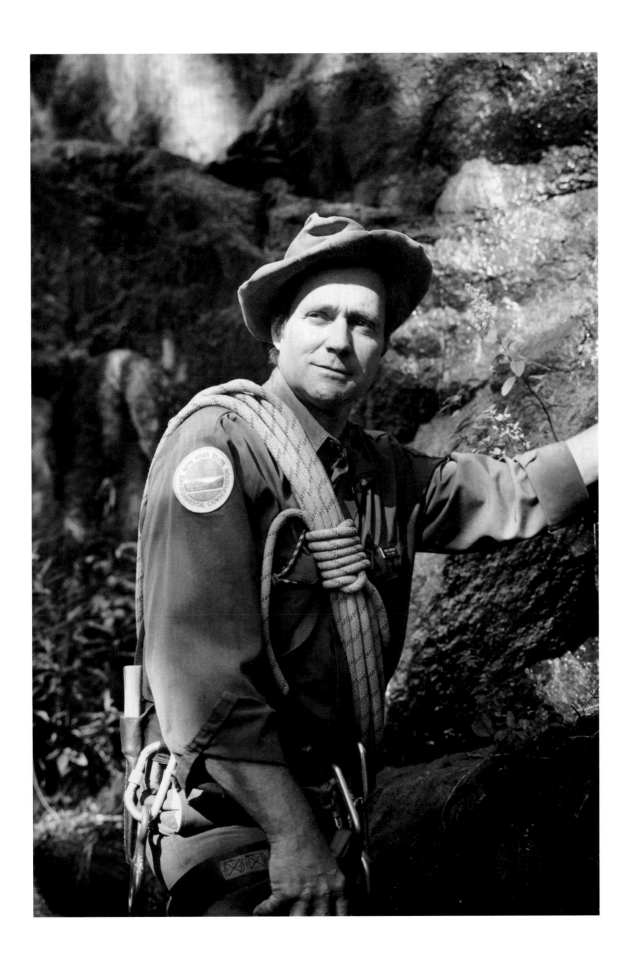

Ranger,

Rescue Specialist

Lake Placid, New York

August 1987

HENRY KASHIWA

HANK KASHIWA came to the Adirondacks by way of British Columbia. A graduate of the Syracuse University School of Forestry in 1946, he and his wife Miriam, whom he met at Syracuse, moved to Old Forge in 1950. After first seeing the town, Hank phoned his wife. "You wouldn't believe it. It has churches, schools. . . . The children are like little sand fleas on the mountain in the wintertime. All the parents stand at the foot of the hill and watch the children ski down that hill. We've just got to really try here."

The Kashiwas raised five children in Old Forge while Hank worked at the Old Forge Hardware Store, a North Country emporium with a widespread reputation. According to Miriam Kashiwa, people would fly in from Westchester to do their Christmas shopping there. "We will send anything anyplace. We've sent a cast iron stove to the Virgin Islands." Of Henry she says, "He has this tremendous need to be productive. He does his best and he expects the best of everybody else. Even a clerking job in our store is not a mindless job. You have to make decisions and meet the public. It's short-order hardware . . . because you have to be quick and you can't stand around and visit all day."

About doing a good job, "he's taught them [his children] by example. He hasn't done a lot of preaching. And he's tried to teach the people at the store, too. He wants them all to be wonderful. And he can't really make a merchant out of a lumberjack. . . . People come up here to be in the outdoors and so it's really very difficult."

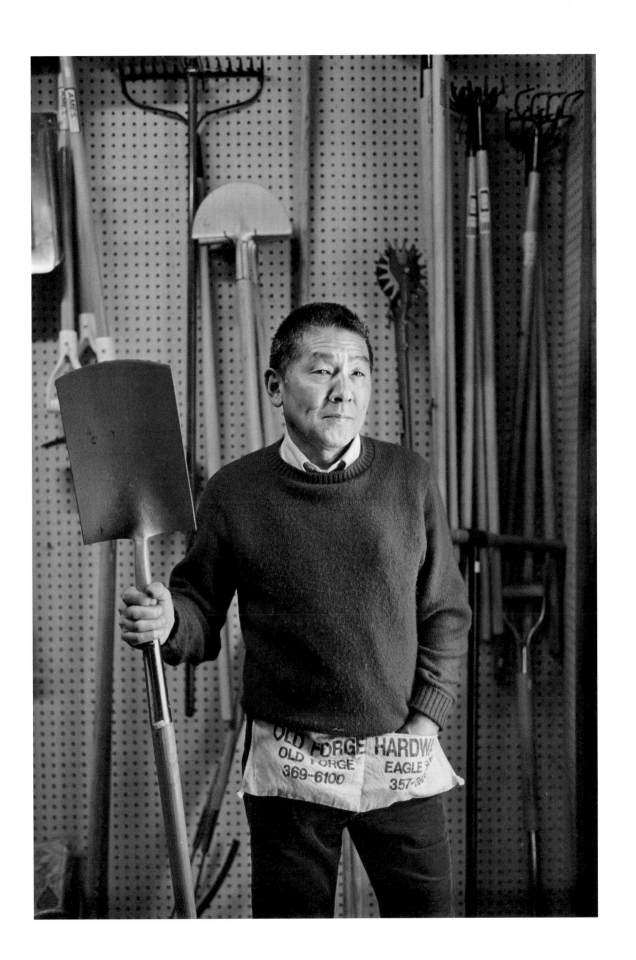

Hardware Store Manager

Old Forge, New York

January 1987

TED KAUFMANN

ORIGINALLY from Long Island, Ted Kaufmann, who "comes out of retirement at the sight of something green," moved to the Adirondacks in the 1960s. He learned dowsing from a "water witch" when he was scouting out a well for his house in North River. "She put the stick in my hand, put her hand in the middle of my back, and gave me a push. . . . I got a signal."

Kaufmann's success with the dowsing stick has developed into an avocation. Although local officials weren't entirely convinced when Kaufmann located a criminal in the town of Wells by "map dowsing," they have since called upon him numerous times to help find missing persons, from the occupants of a truck that broke through the ice on Lake George to a young man who hanged himself deep in the woods in a hemlock thicket. Kaufmann prefers the occasional lost hunter who builds a fire and waits to be rescued. "I like it when I can find them alive," he says. "Much, much more satisfying."

Kaufmann is reluctant to claim that his ability is a psychic gift; he thinks of it rather as something he can do for his fellow man. "I can only say that the whole phenomenon, it's not frightening at all, but it does lift your imagination beyond the daily things. Dowsing has opened a complete new vista for my life. Here I am, I'm seventy-five, I feel like a kid because of this delightful thing. I feel that it's a genuine service. It is a joy of accomplishment."

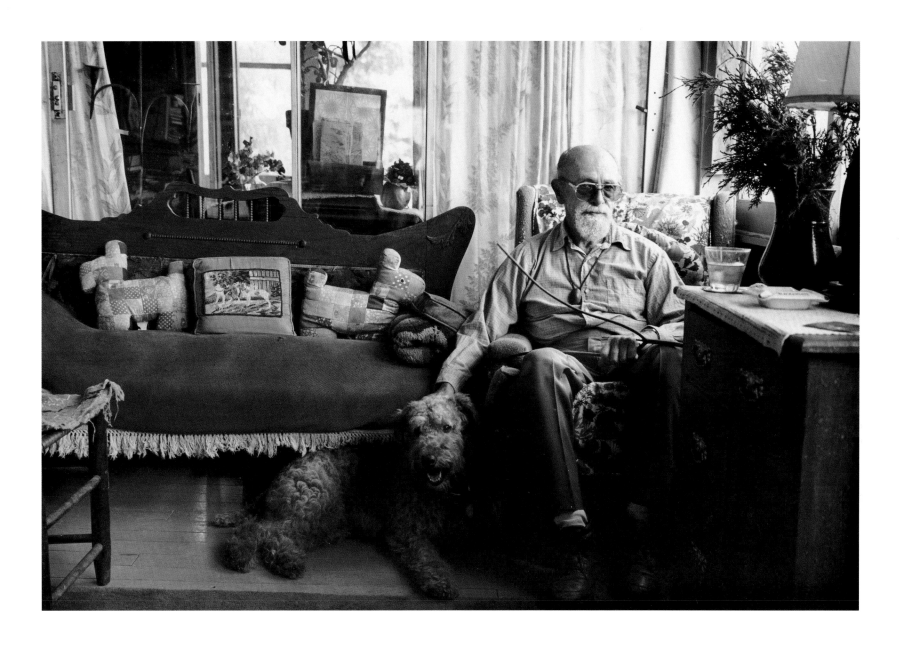

Advertising, Public Relations,

Dowser, Finder of Lost Persons

North River, New York

June 1987

VICTOR KIBLER

FIDDLER Victor Kibler, whose family has lived in the Adirondacks for generations, grew up on a farm without electricity, radio, or television, but with plenty of music. "We amused ourselves nights by my mother sittin' down to the old pump organ and my grandfather and my uncles fiddlin'." His French-Canadian grandfather did carpentry work across the border in the summertime, where he picked up tunes from Canadian fiddlers. "My grandfather was the greatest fiddler I ever heard."

Kibler, who has been playing since he was thirteen, credits his grandfather for his repertoire. "I have around five hundred tunes probably. I judge fiddle contests, I give lessons, I run a little garage. In between jobs if I can get a chance I whittle off a couple of tunes just for practice. Course then somebody come in they laugh at me, so I have to put it away. It's a scene that they don't usually see, you know, and I suppose . . . they're amazed by it probably."

Although he has taught auto mechanics, fiddling and teaching fiddling is still a main part of Kibler's life. He and his son Paul, who plays a "fantastic piano," regularly attend folk festivals. "I play everything," says Kibler. "Two-steps, polkas, reels, hornpipes, jigs, rags, waltzes, clacks. All the tunes. Anything I'd get a hold of I'd play."

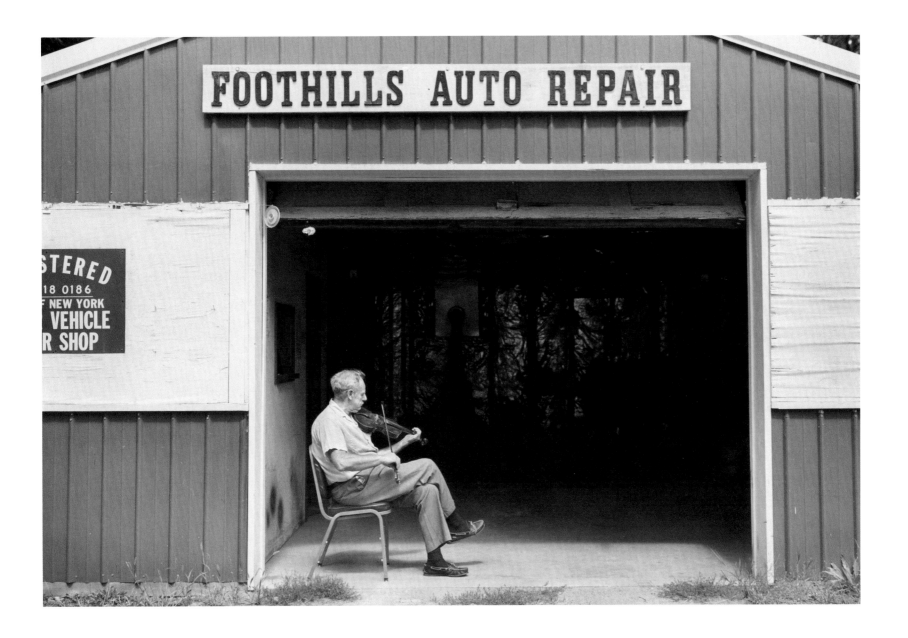

"Adirondack Fiddler," Auto Mechanic

Gloversville, New York

August 1987

ERNEST B. LAPRAIRIE

ONE BRANCH OF Ernie LaPrairie's family settled in the Adirondacks in the 1860s on a farm at the confluence of the Indian and Hudson rivers. "They sent off sons to the Civil War [who] came back. Which was kind of unusual for that particular war and time." A fifth-generation Adirondack guide, Ernie manages the Hudson River Rafting Company in the spring and fall and runs his own guiding business in the summer. "I think they [his family] lived here because they loved being outdoors, and that's where I'm coming from, you know. I like the woods, I like being outdoors, and I like doing things outside. What I try to do with my canoe trips is to get away from the traditional guiding aspect of taking people into the woods and cooking for them, caring for them, singing songs at night, putting them to bed. I try to use my guided canoe trips as a learning experience for people, to instill in them a love and respect for the wilderness and for the outdoors.

"We have all this wilderness area available to us, [but] most people don't see more than a quarter of a mile away from a given road or trail. Very few people actually get into these wilderness areas and experience them. . . . It's getting harder and harder to find areas that aren't being used," he adds. "When we find one I don't generally tell anyone about it."

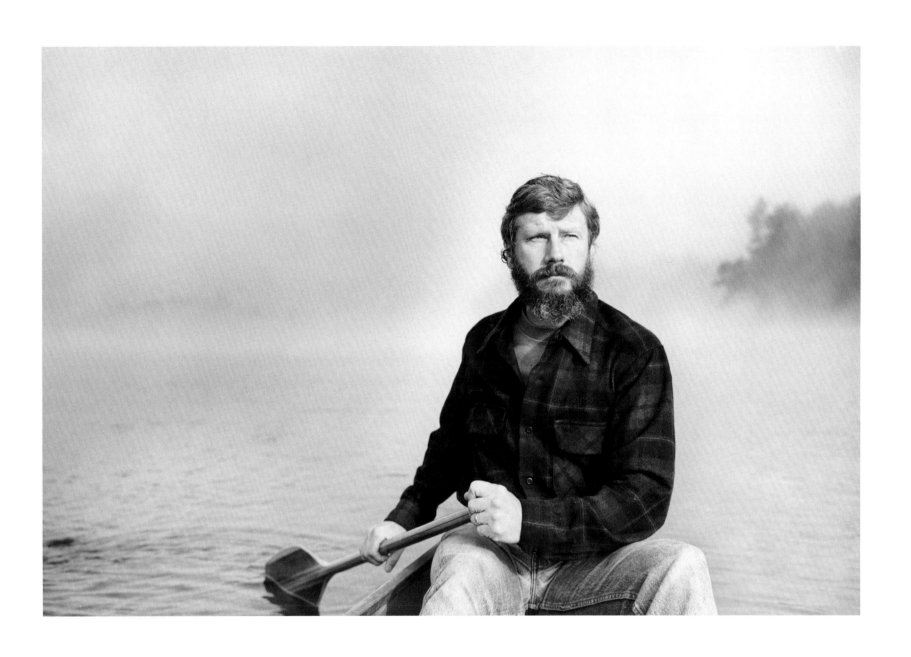

Outfitter, Guide,

Rafting Company Manager,

Competitive Canoe Racer

Blue Mountain Lake, New York

June 1987

JAMES A. LATOUR

Jɪᴍ ʟᴀᴛᴏᴜʀ returned to his native Saranac Lake after World War II to go into the fuel business with his father. Fifteen years later he "went back in the woods to work where I figure I belong. . . . The spruce and the hemlock, they don't talk back to you." Eventually he bought the sawmill.

Besides cutting dimension lumber, he cuts stumps for making guideboat ribs. "You usually dig them out," he says. "You can't pull them or anything because you'll stress them, you shock the fibers of the material, so if you do that, it's useless because it takes a lot of the strength out. The root is a good piece for your guideboat ribs, because that is the strongest element of your tree; it has taken the abuse of the rocking and shaking."

Latour points out that his mill, an older type, is more versatile than one that is fully automated. He can retool quickly. The logs he saws for boat builders are quarter sawed, rather than slash sawed across the grain. "Quarter sawing . . . is sawing with the grain, so if you're bending that particular piece of lumber, it isn't gonna split or check or go out on you. There's not enough experienced people around the country today that knows how to quarter saw, and I think we're at a premium."

Latour once worked as a logger in a camp in the Big Moose Lake area. "Lived in a big bunk house, had wonderful food, the best food in the world, and about the only place in my life that I ever went into that at the table you never swore, you was always very polite. If you reached over somebody's shoulder to grab something you always said 'pass me the meat' or 'pass me the potatoes' and said 'please.' Because if you didn't, you might get a fork right through your hand, the cook was the boss."

While he complains about mechanized logging and the destruction of the forest caused by machines, he blames "environmentalists" and the Adirondack Park Agency for imposing too many restrictions. "So where's your balance?" asks Latour. "I mean in the old days when I was a boy with my father, we left so many trees, we didn't have any foresters, we didn't know what a forester was. People that were in the woods, which they call themselves lumberjacks, they were the ones that did the reforesting, they saved the Adirondacks, many of them. Because if I cut trees in a certain area, they'd say to me, 'You leave so many big trees there for reseeding. If you don't, I'll kick your rear end till your nose bleeds, my boy.' That's the very words we got."

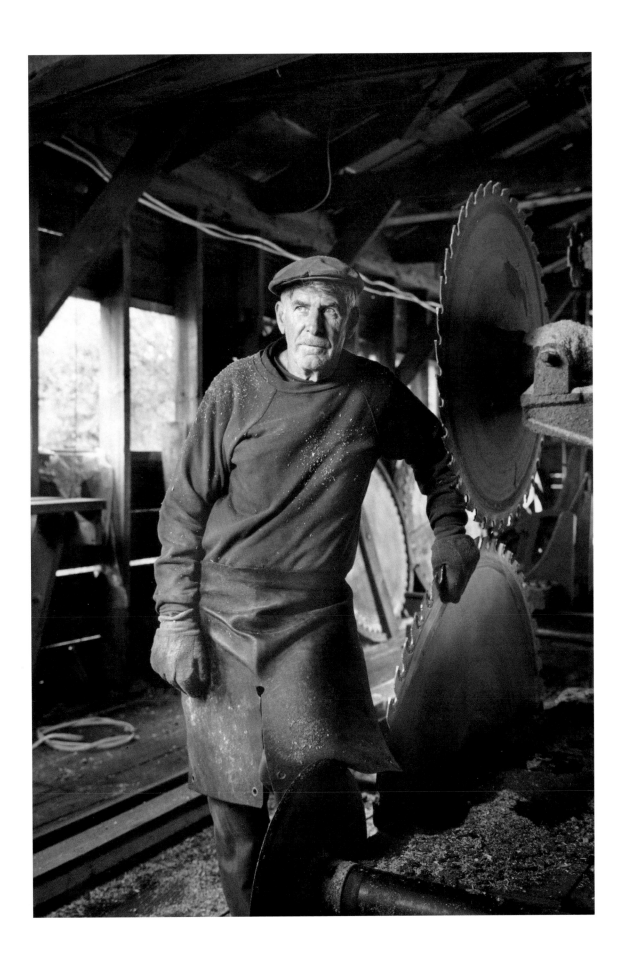

Sawmill Owner,

Former Logger

Saranac Lake, New York

December 1986

RICHARD W. LAWRENCE, JR.

Richard lawrence, jr., born in the Bronx, has lived in Elizabethtown since 1947. "I can never be a native," he says. "My children are." Devoted to protecting the Adirondacks and preserving their history, he is also concerned with promoting education in the region. Among his many offices, Richard Lawrence has served as first chairman of the Adirondack Park Agency and as president of the Bruce L. Crary Educational Foundation, which provides assistance to Adirondack students unable to afford college tuition.

Lawrence has seen an enormous growth in educational interests and institutions, including the Adirondack Museum, since he's lived here. "There are many more amenities than there used to be," he says. "The people who have moved into the area have come and brought great talents with them and a highly different set of standards and education. They make sacrifices to come here, but they are very important additions to the community."

Lawrence has served on two study commissions on the Adirondacks: the Rockefeller Commission in 1969 and Governor Cuomo's Commission in 1990. Although he's disappointed in the way the last commission report was released and in the short length of time, one year, in which the study took place, he believes it contains riches that will be tapped one day. His main complaint is with state management of wilderness areas. Too many people are allowed in the Marcy area while other areas, like Giant and Dix, are empty. "It's a matter of educating people as to where they can go and have a perfectly marvelous time." Asked how many people the Adirondacks can absorb, Lawrence replied, "Thousands. Absolutely. We are so enormous—there's no other comparable forested area with mountains and lakes. [People] can't begin to hurt [the ecology]. Except when you get herd paths, the ones in the Marcy area." The establishment of the Forest Preserve and the Adirondack Park "was a tremendous rescue effort to save the Adirondacks from the dreadful devastation from logging and entrepreneurial types. And now [the growth] is all coming back beautifully. Oh, there must be a dozen plots which you'd definitely call virgin forest—big old sons of guns sticking up in the air—but not very many."

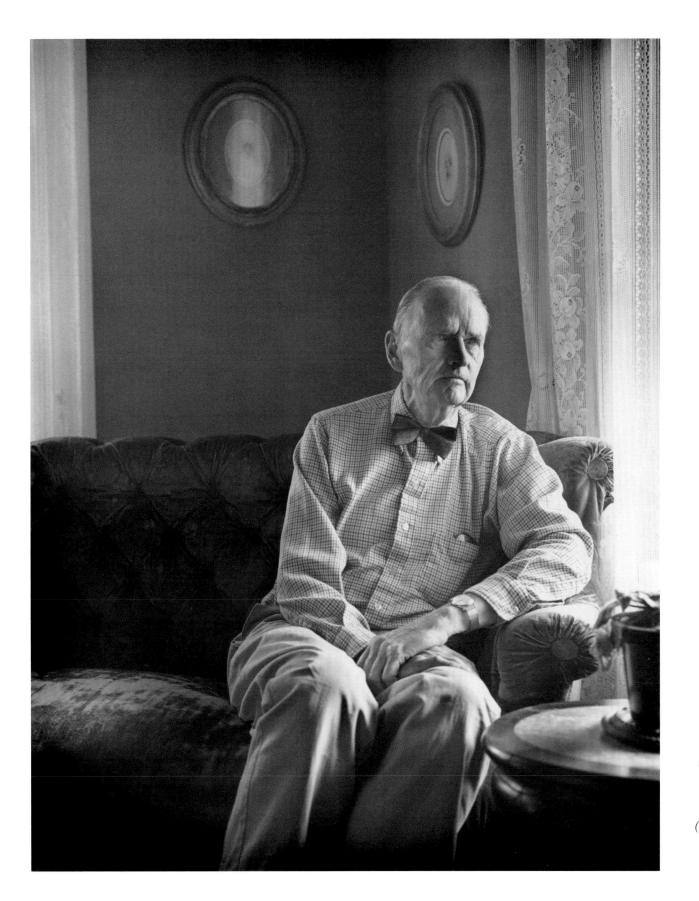

Lawyer, Preservationist

Elizabethtown, New York

September 1987

(interviewed October 1990)

MATTHEW LONCAR

MATTHEW LONCAR got his idea for building an Indian village from attending Tom Brown's Tracking School in the New Jersey pine barrens. "He teaches on the Indian philosophy of survival . . . of not going out with guns and defeating the woods and tearing things down all gung-ho and stuff. He's more on how to live with nature and take care of it. We got the sweat lodge here because it's a really good spiritual lifter. Building the wigwam because it's a nice shelter you can sit in and enjoy the fire without your shelter burnin' up on you. [It's] taken me and my friend Dave Binder three years to build . . . like a week or two out of every year, worked on it.

"From what I understand," says Loncar, "the economy's going to go really bad, all right. And you're not gonna be able to rely on your grocery stores to feed you. . . . I'd like to change over to the outdoors totally but you can't live in the outdoors, I mean, with society today. There's more houses bein' put up. I have a car I got to pay insurance on, that keeps me at work. It gets frustrating because, I don't know, I'm fightin' between two different worlds, society and here."

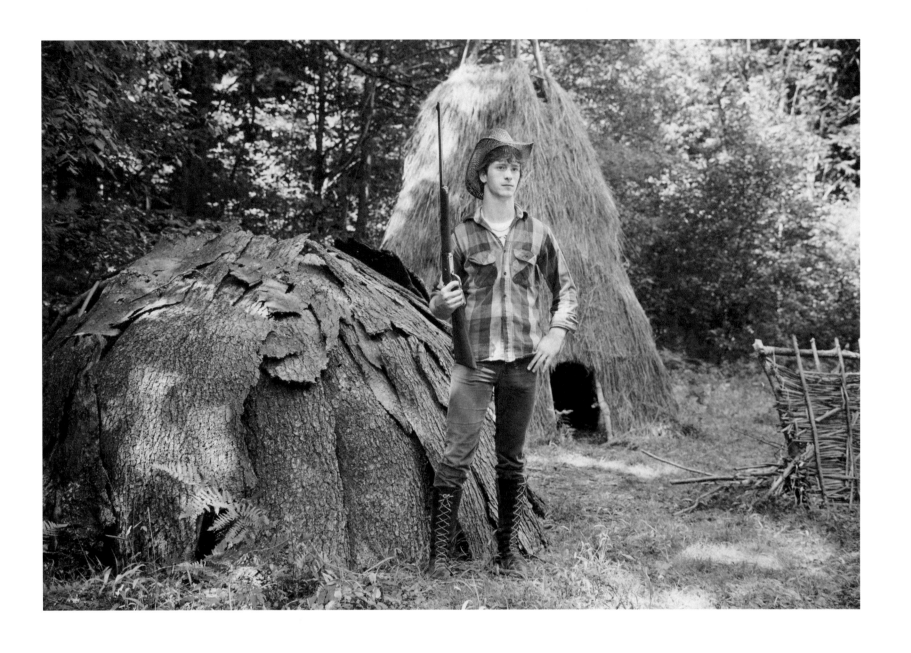

Naturalist, Survivalist,

Body Shop Worker

Athol, New York

August 1987

EMANUEL MAROUN

Emanuel maroun's grandfather came from Lebanon in 1893 and earned his living peddling household goods, carried in a pack on his back, from lumber camp to lumber camp. A circuit from Tupper Lake through Piercefield and Cranberry Lake and on to Saranac Lake and back took about five days by foot. "They carried everything [into the lumber camps], pins, needles, clothes, household wares, pots and pans . . . shoelaces and the works." In 1920 the Marouns bought a Model A Ford and peddled by car. "Put all their goods in back in the car and go—they didn't know the language. It was very hard times." They opened their first grocery store in 1937 and the current one in 1946, "same stock, same lot.

". . . My dad went back [to Lebanon] in 1928 and got married," he continues. "Brought my mother over here. And I went back in 1966 and got married to my aunt's daughter. So it's all in one family. My father married his aunt's daughter, I married my aunt's daughter. On the father's and mother's side, the same family. . . . I wouldn't want to lose my identity, no, not a bit."

A strong Lebanese community, about fifty to sixty individuals whose forebears first came from Utica to Tupper by train, still exists in Tupper Lake, says Maroun. Few have married outside their nationality. "They still carry the tradition, like the dishes, the same foods . . . [the children] all talk Arabic. . . . We carry the tradition really heavy here."

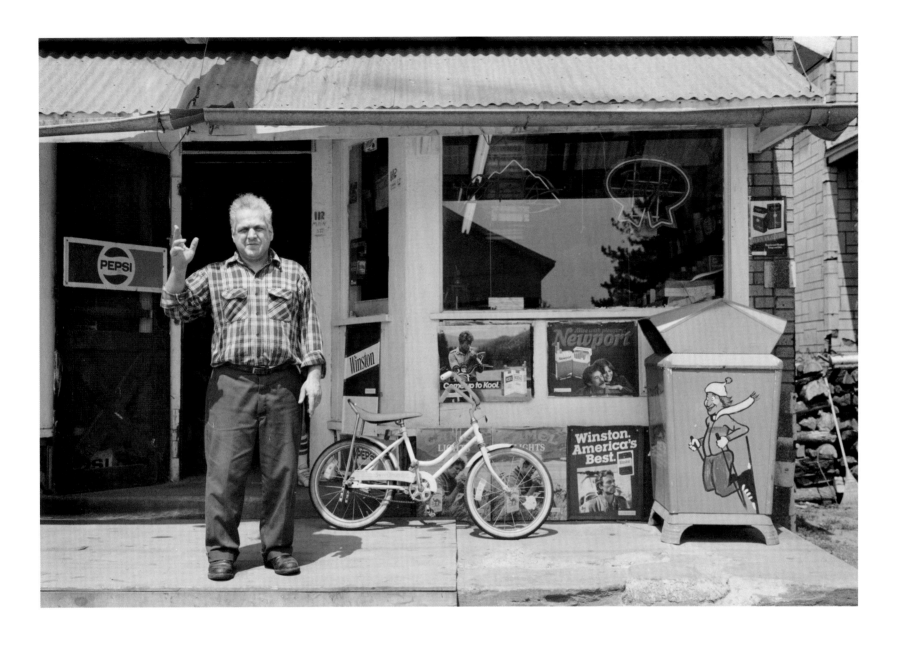

Grocery Store Owner

Tupper Lake, New York

September 1986

ADA MCDONALD

ADA MCDONALD'S son Dan remembers that his parents bought their store in 1926. His father minded the store seven days a week; his mother Ada, with six children, was in and out. "We had the pork barrel and the cracker barrel, and a stove in the middle with guys sittin' around playing checkers. And we had an old radio in the corner. I remember that we had a blind guy lived in town. He knew where the switch was, and he was the one who operated the radio most of the time.

"Everybody come to town on Saturday night," Dan recalls. "They'd buy seven or eight or ten loaves of bread. Eggs used to come in a round barrel, just loose, you know. Instead of puttin' sugar in a bag, they'd put a piece of paper on the scales and pour the sugar in there until they got what they wanted and wrap it up in paper. And lard used to come in a barrel. You'd [dig it] out with a special knife and put it in containers. And flour, another big item. Most everybody bought flour by the barrel, everybody at least a twenty-five-pound bag. Sugar barrel used to be under the counter here. And milk, we used to furnish, we had a couple of cows, and we used to strain it, bottle it, and bring it over here and sell it."

When people in the area were hard up, the store, an IGA member, extended credit. "Dad used to . . . after somebody would die he'd mark [the receipts] 'paid by God' and throw them in the basket. A lot of 'em. I remember one fellow, he was here every day—he had an ear that was gone. And the story was that a horse had eaten it off. You know, bit it off. So that will always amaze me, because I was just a little kid."

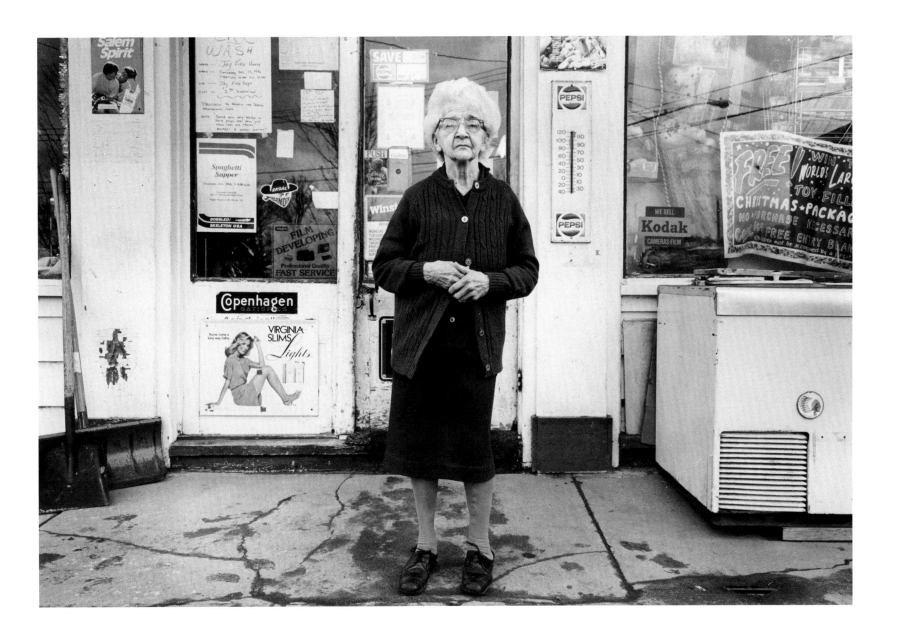

Storekeeper, Postmaster

Jay, New York

December 1986

EDITH T. MORCY

Her mother was one of the first women guides in New York State; her father, O. C. Tuttle, built a hotel on Fourth Lake and guided for J. P. Morgan. "J. P. wouldn't go fishing unless my dad went with him. And they'd sit in the guideboat, and there wasn't one that was better than the other. J. P. with all his and my dad with very little were of a kin when they were out together like that. My dad liked to chew tobacco so J. P. would chew tobacco with him. And they would have a great time together."

A licensed guide herself, Edith Morcy has lived and fished in the Adirondacks more than eighty years. "The bass come in late at night to feed around rocks and stumps. And if it's a moonlight night it's fun to see them. They'll dance right on top of the water on their tails, the bass will, trying to shake that bug."

Tuttle's Devil Bug, a lure invented by Edith Morcy's father and named by her mother, was sold nationwide and in New York City at Abercrombie's. Edith and her husband marketed it for years afterward until the restrictions of running a small business forced her to sell it to a company in Saginaw, Michigan. Discouraged with speedboats on the lakes, Edith retired to a "so-called cabin in the woods," where she tames but does not feed the deer and allows mink and blue herons to steal brook trout from her pond.

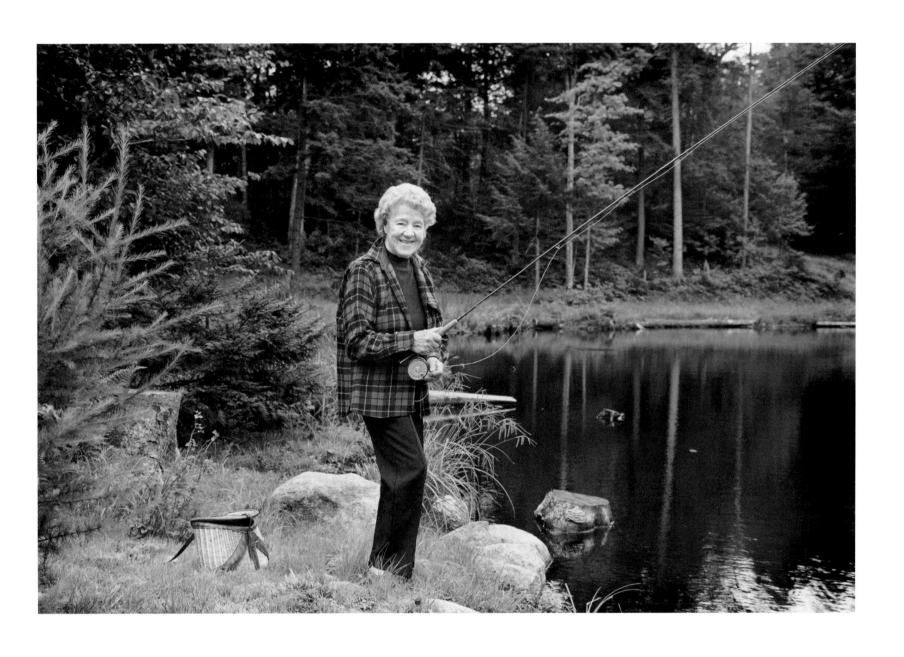

Adirondack Guide, Fly Fisher,

Businesswoman

Old Forge, New York

July 1987

NORA J. NEWELL

Nora newell's grandfather guided for Paul Smith and her father for Marjorie Merriweather Post at Topridge. Although her parents moved to Maryland, Nora came back to live in the area when she was twenty. "The first thing that made me think it was so wonderful was the size of the rocks up here. In Maryland we have no rocks. And then I think the snow—we never had snow at Christmas time. I wanted to build [this house] when I was probably seven. And I wanted to be a caretaker at twenty. That's the big thing up here in the Adirondacks. And women aren't caretakers in the Adirondacks. So that was my big accomplishment."

Nora built first a lean-to, then a house, on property belonging to her parents. She cut the logs herself, "with a chain saw and an axe. And I pulled them out with a rope and woman power." The walls of her house, built with more than two hundred red pine logs, were raised by hand. "And I ended up not with eight foot ceilings, a proper ceiling height, but [a] range from seven foot four inches to seven foot. Because by the time we got to that height I said I don't know anybody eight foot. And I cannot lift another log."

Nora's parents, who once worked for William Rockefeller, owned property near the Rockefeller estate. "And he had donated this old schoolhouse just down from this house, and they had swings. I'd go down and swing on those swings. And I remember Mr. Rockefeller would always wave. I may go away for the winters as I get older, like most people do here," she continues, "but I believe this will be my home now. I have lots of attachment to here."

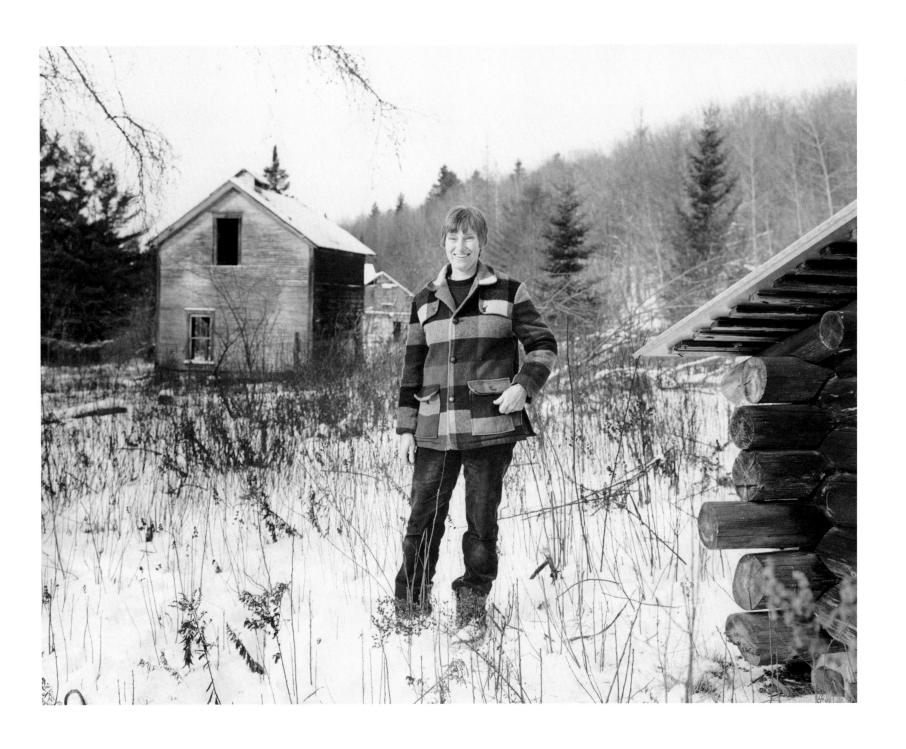

Log House Builder, Caretaker

Paul Smiths, New York

December 1986

PAULINE C. NEWELL

Pauline newell's grandmother helped her make her first quilt, a flying geese pattern, when she was ten years old in 1909. Since then she's made countless hand-sewn quilts at "odd times" while raising five children and seventeen grandchildren. She has made quilts for each of her children. "I gave Nora one because Nora's been awful good to me and I love her."

Newell has never exhibited her work at a crafts fair. Her quilts are all made "the old way," by hand, and she doesn't count the hours she spends on each one. She sometimes has two or three going at once. "I do it for pleasure and I've always done my own work, you know. I wouldn't want to sell a quilt. There's too much love. I'd rather give them. I sold one for two hundred fifty dollars and I've always been sorry."

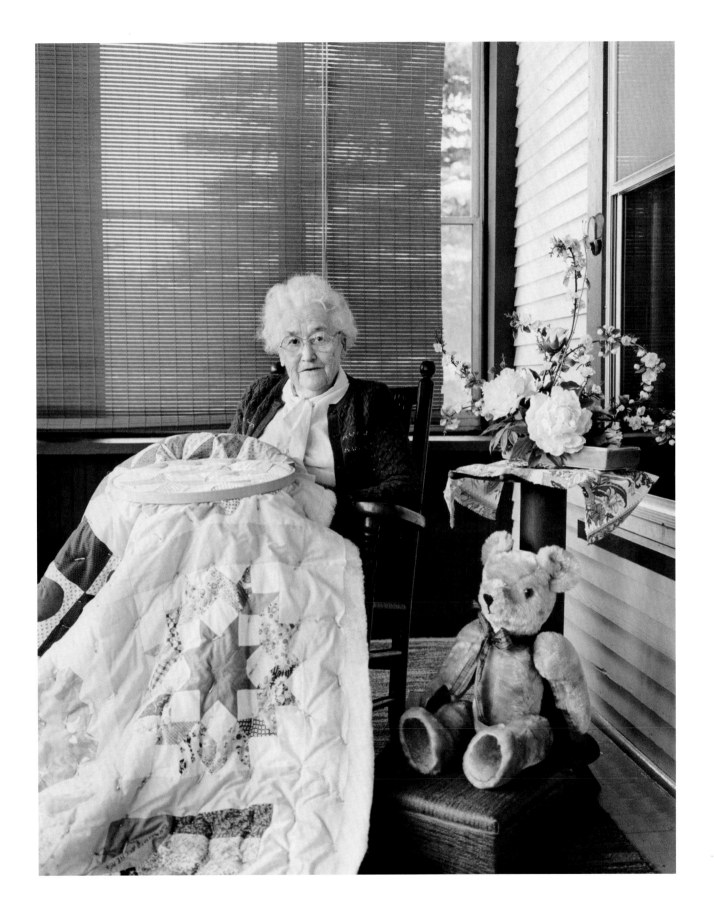

Quiltmaker

Paul Smiths, New York

December 1986

FRANK OWEN

FROM NEW YORK CITY, Frank Owen has been living and working in the Adirondacks since 1981. Keene Valley is "a charming community," according to Owen, "a small village with just enough people, many of whom are very interesting, all of them are positive." Owen believes that a certain group of people are growing in the Adirondacks, those who have made their livings outside the area, have moved here, and are linked professionally to their various marketplaces through computer networks.

"The really distinctive difference [between Keene Valley and New York City] is a shrinking of external stimuli but a real expansion of my territory," he says. "I think that the phenomenon most reflected in my work has to do with the density of the wilderness, or of nature. A close-up kind of vision of things. Most people tend to think that art treats the big vistas in the Adirondacks, the sweeping scope. And I'm more interested in the small disasters of breakages and windfalls and thickets . . . that operate on a level that a human being really experiences as you move through the trees, ducking branches at eye level."

Although Owen's art is abstract, nature intrudes in various ways. "Some of these geometric forms that are prominent in the painting are really echoes of what I'll see right out my studio window in the wintertime, when the branches are covered with snow and everything is just very stark and spiky. The artist's life," he continues, "is presumed to be one of great freedom; you can go anywhere, do anything. You're free to do anything you want, and then the question is, what's worth doing? That's the killer question."

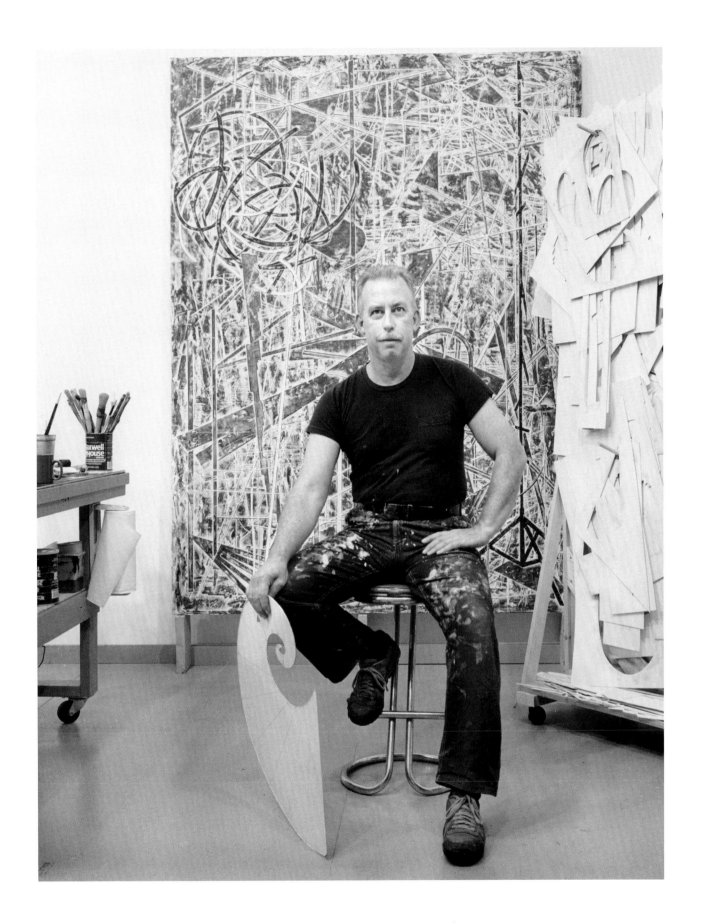

Artist

Keene Valley, New York

August 1987

JAMES GLENN PECK

THE AUTHOR of two collections of stories and poems about the Adirondacks, Jim Peck has been a hunter, trapper, and student of nature all his life. "It wasn't as if I had to seek out my wilderness ways," he writes. "They molded my life. . . . Nature and the wilderness are harsh teachers. . . . Do it right the first time or you will pay the cost. Hard though this may seem . . . it builds into one such qualities as I see fading in modern man with his genuine plastic society. . . .

"Man comes here to get away and the first thing you know, he has to build a road so it's easier to get here. Then he has to have a house complete with indoor plumbing and, of course, telephone wires and electric poles. He has to have a store so it's convenient and his friends have to join him. The first thing you know, everything that he left on that side of the mountain is on this side of the mountain. On it goes until all the valleys look alike. . . .

"Surely civilization is making inroads to the mountain wilderness; with each day that passes I find many new faces in the forests. If by chance you should see me or one of my kind clad in buckskins and carrying the long rifle, look well and remember for, like the dinosaur and the mountain wilderness itself, I know our days are numbered. As the wheel of time turns full circle, like the Indian, we are a vanishing breed" (excerpts from *Night Camp: Tales of the Adirondacks,* by James Glenn Peck, 1987).

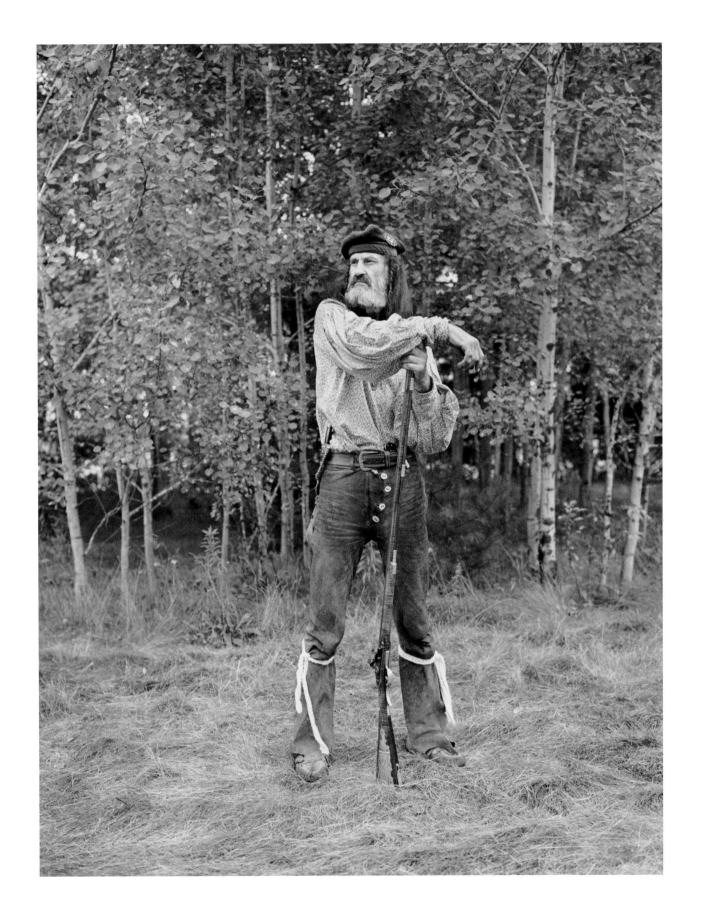

"High Countryman,"

Author, Lecturer

Caroga Lake, New York

September 1987

ARTHUR PFENDLER

"A LOT OF PEOPLE in Boonville belonged here . . . the old timers," says Fritz Pfendler about the Forestport Oddfellows Hall, used from 1903 until the 1970s. "When I took this over, there was a lot of old uniforms and stuff they used in their rituals, you know. They had a coffin and a plaster of paris skeleton in there. I sold it to a junk dealer."

Pfendler worked as a logger in the 1930s and for seven or eight years had his own horses. He loved the work because he loved horses. From 1937 to 1939 he drove logs on the Moose River. "We used to run along the bank to push 'em in. And you were soaking wet all day and all night. When the dam went out at McKeever [1948], that was the last drive."

Pfendler was one of the last to live in a lumber camp when sixty or so men and thirty teams spent entire winters in the woods. Pay in the 1930s was three dollars a day with no limit to food on the table, and a man worked dawn to dark. The river boatmen and lumberjacks, many of them Polish, French, and Irish, Pfendler holds in high regard. "They were wild, good people," he says. "Today it's altogether different. You go home, get up in the morning and get in your Cadillac, and go in the woods and cut a tree down and come home."

Pfendler cut mostly soft wood, which could be floated downstream. "Walked right through the hard wood." Now, he says, "They drive into where the logs are and they chop the trees down, a guy comes along in a big skidder, they yank the whole tree right out. . . . They don't leave nothin'."

Given his choice between a machine and a horse, Pfendler would opt for the latter. "I'd rather be with a horse than any skidder, anything." He's owned one new car in his life, a Mercury, circa 1940. Although he cruised timber in the Colorado Rockies for awhile, he's stayed in the same area in the Adirondacks most of his life. "I never had to go lookin' for jobs. I had a chance to go overseas on them big towers, iron work, but why should I go, I was makin' all I could spend here?"

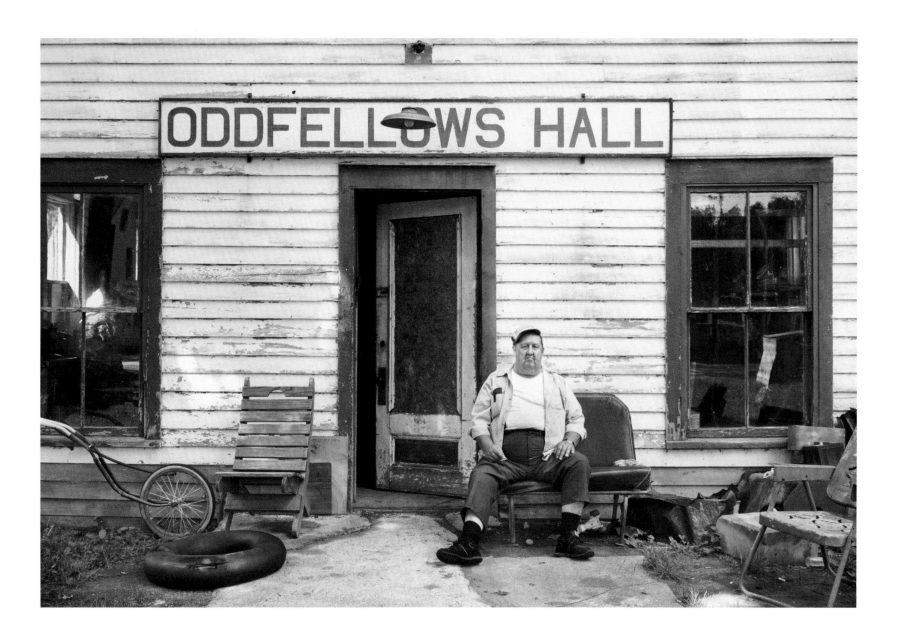

Lumberjack, River Driver

Forestport, New York

August 1987

MICHAEL S. PINARD

With a degree in resources management, Mike Pinard works for his father, a French-Canadian who runs a small independent logging operation employing a dozen men at the most. "We usually have two-man crews. One man cuts the trees down and cuts the limbs off. Another man runs the skidder, and he goes back and forth pulling the trees out of the woods to the landing, where they're cut up and loaded on a truck."

Work in the woods, twelve hours a day year-round, is "very physical [and] dangerous at times," according to Mike. "You buy your own chain saws and gas . . . there aren't any health benefits unless you pay for them. There's no vacation time or sick days or anything like that. You get paid for what you put out every day that you work."

Yet, for Mike, the woods offer more than just a living. "Well, for instance, last week I got off my skidder, and not three feet away from my machine was a fawn that couldn't have been more than two or three days old. I usually carry a camera on the skidder, so I started shooting away and I put my hard hat next to him for size comparison. And he could just about fit inside my hard hat. Things like that happen, it makes it worthwhile to work at this."

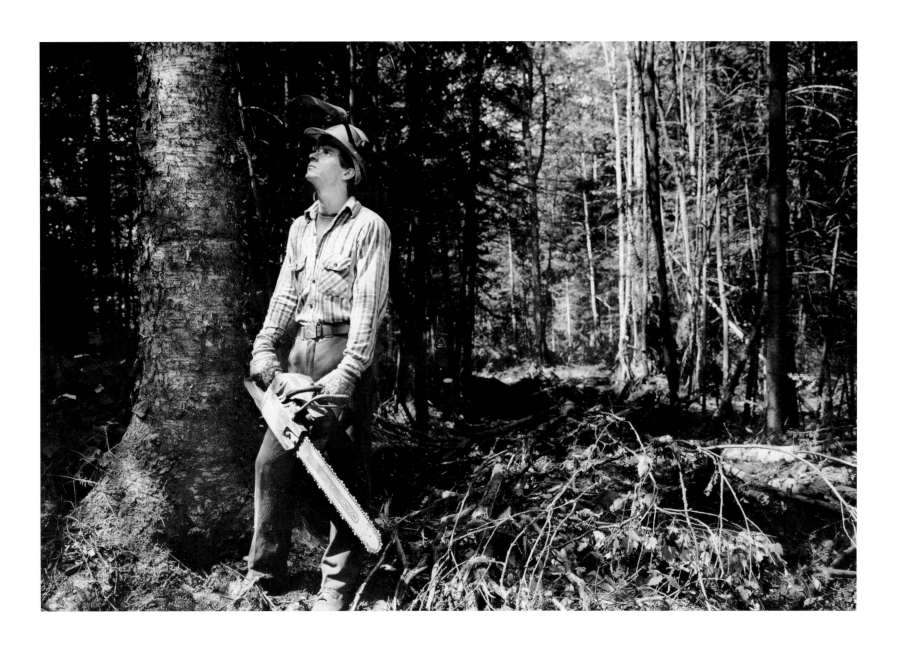

Logger

Long Lake, New York

June 1987

WILLIAM J. REGETZ

I LOVE THE high mountains, they were where I was born," says fur trader and trapper Bill Regetz, who was born on a farm in Constableville in 1898 where his son now lives. Regetz has been in the fur business sixty years. "I trapped skunks and muskrats, they were easy to catch. And I paid a man from Canada to show me how to catch foxes. Because the first year I tried I caught seven. The next year fifty-two."

During the Depression, Regetz sold furs from his roadside place to tourists, who could buy them cheaper than in the city. New York dealers would come every week to buy raw furs, he says. Now Regetz sells tanned furs mostly to tourists who stop at his house.

Regetz stopped "spot trapping" when he was seventy-five, although he continued to buy furs from local trappers. He did not use a car but walked from trap to trap, about one hundred in all, which he checked every other day. "I think I did very well in my lifetime," says Regetz. He plans to leave the money he made trading furs to his two sons, so they "won't have to work outside."

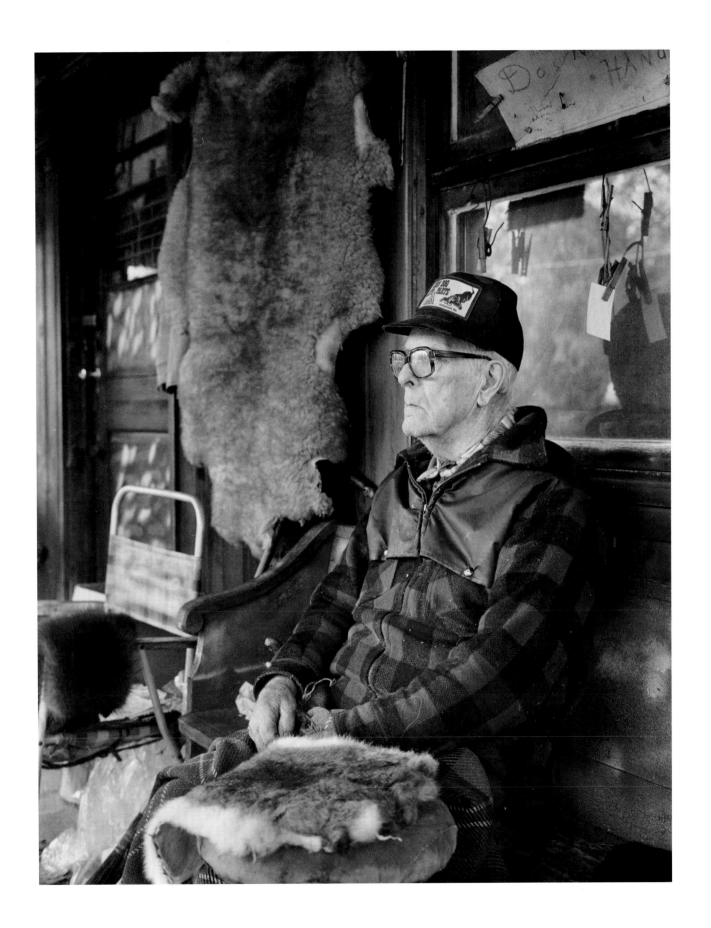

Fur Trapper, Trader

Boonville, New York

September 1986

JAMES W. RILEY

JIM RILEY, who works for the State Highway Department during the week, is a flea-market dealer on weekends, one of a "brotherhood" of vendors who meet in the Platts-burgh, Saranac, and Tupper Lake area about a dozen times a summer. "There's a lot of characters in this business and we just have a good time together," he says. "It's sort of a social activity for me. I like meeting people, talking with them, and enjoy dealing in old items, antiques, semi-antiques. Some people call it junk, but one man's junk is another man's treasure, I always say."

Asked how long his family had been living in the region, Riley answered, "We're all natives. We've been here forever. My grandfather was here, had a store in Gabriels. My father was born and raised here, and I've been born and raised here. I got four brothers. We're all still around here. You couldn't get me out . . . took a ground chain, you couldn't drive me out of the Adirondacks."

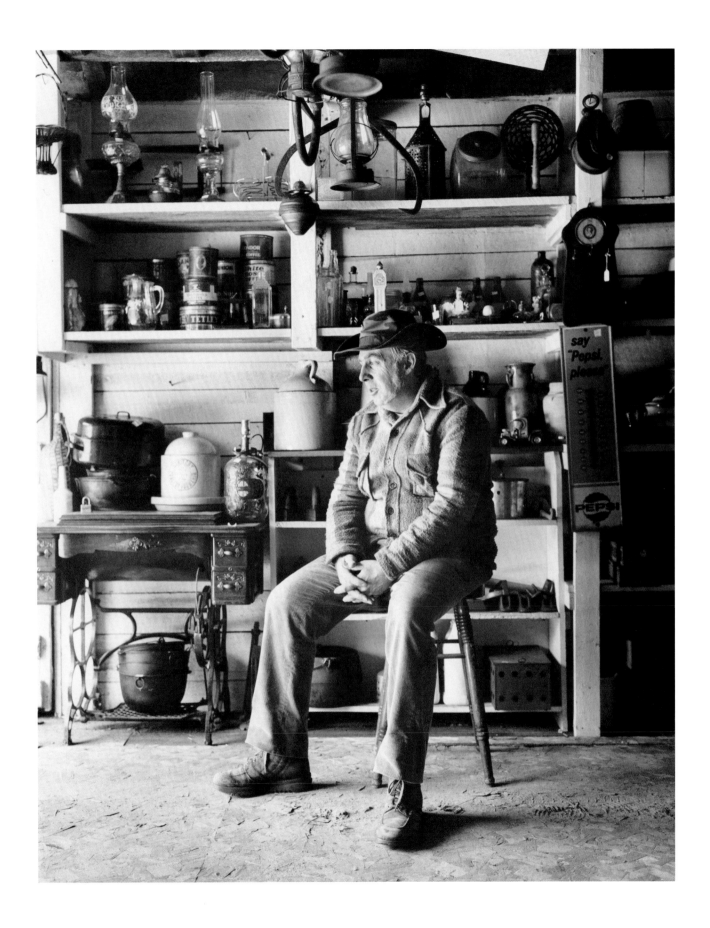

Highway Worker,

Flea Market Dealer

Gabriels, New York

December 1986

LINDA RUNYON

LINDA RUNYON first became acquainted with the Adirondacks as a child when she
was tethered to a tree at her grandfather's tenting tourist camp on Indian Lake. "So I
learned to eat the weeds that way." She turned exclusively to wild food after her summer's
preparation of four hundred twenty jars of canned food exploded in an Adirondack freeze-
out. "It took approximately eight hours a day for the entire summer to can fifty different
foods, traditional canning, over a campfire with a very heavy-duty pan. In one night they
disappeared. It was forty below, and it [felt like] one hundred twenty below in chill factor
in the camp. And it was a seven and a half foot pit that we had dug for these canned goods,
and it was all insulated and sheltered and whatever. They absolutely exploded, stalactites,
stalagmites hanging down seven shelves underground. Because the Adirondacks is a unique
place. The permafrost is quite deep . . . you can't have glass goods, in a traditional fashion
of a dug pit. Perhaps in a hillside it might have worked, but it did not work on the lay of
the land next to Cedar River. And in one night the food was gone."

A strict vegetarian, Linda has sustained herself for many summers by the weeds in a
rototilled strip forty feet long by one and a half feet wide. "I call it a food field," she says.
Living off the land is not limited to the growing season. "There are weeds everywhere
underneath the ground in wintertime. You can scrape away the snow and with a spoon
dig up a Queen Anne's Lace plug, I call it, or a dandelion plug. That will grow in water
and it will grow if transplanted. . . . We have an overabundance of everything that
could possibly be needed as a food source."

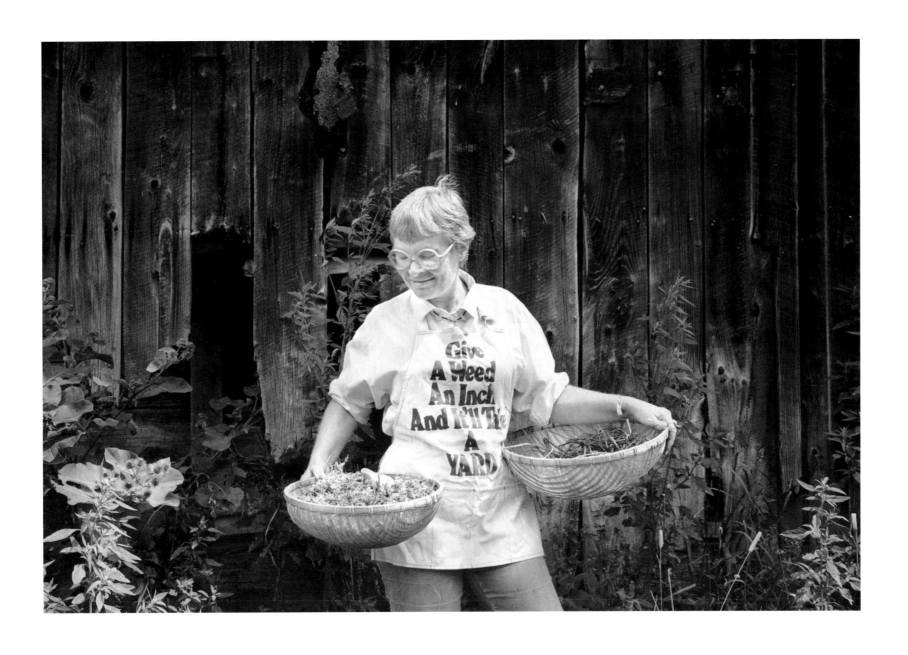

Nurse, Homesteader,

Weed Farmer, Author, Teacher

Warrensburg, New York

July 1987

ARTHUR V. SAVAGE

A DESCENDENT of the Hand family, a distinguished family of jurists from Elizabeth-town, New York, Art Savage practices law in New York City and maintains a second home in Keene Valley. For seven generations, since 1839, his family have been small landowners in Essex County. A great-grandfather, Augustus C. Hand, who was elected democratic congressman, made the arduous trip from the Adirondacks to the capitol by stage, boat, carriage—which shed a wheel between Whitehall and Albany—and finally railroad in 1849.

Although they no longer live here, Savage and his family feel a constant pull back to the Adirondacks, where they come each summer. He has seen changes. "In its heyday Elizabethtown was a resort," he says. "There were two large hotels, the Deer's Head Inn and the Hotel Windsor, where people would rock on the porch for two-plus weeks. The Depression changed it—[fewer] people were able to get away, and the style of vacation began to change from sitting on porches to a more active life. . . . The automobile was coming, and you weren't entirely dependent on the Delaware and Hudson coming up from New York City. . . . My grandfather, I remember, pulled out a timetable he had found in some old file or archive and indicated that in 1904 it took less time than in the 1940s."

Art Savage, who has been an Adirondack Park Agency commissioner since 1979, sees the Report of Governor Cuomo's Commission on the Adirondacks in the Twenty-first Century, released in April 1990, as "a continuation of the tradition that really enables New York State to claim that it started and founded the environmental movement." Although they've been somewhat restricted, "people in the North Country have always [thought it] their God-given right to do with their property what they wanted," says Savage. "It's been by and large the vast population of the downstate area that has carried the day in terms of protecting the Park. . . . The [Adirondack Park] Agency has not been able to encourage as had been hoped towns to come up with local planning and zoning," he concedes, "but we're moving in that direction. . . . There's a clinging to the old ways, but bear in mind that I think the denizens of the park should be very proud that it's still relatively unspoiled, and has been kept relatively unspoiled for one hundred years."

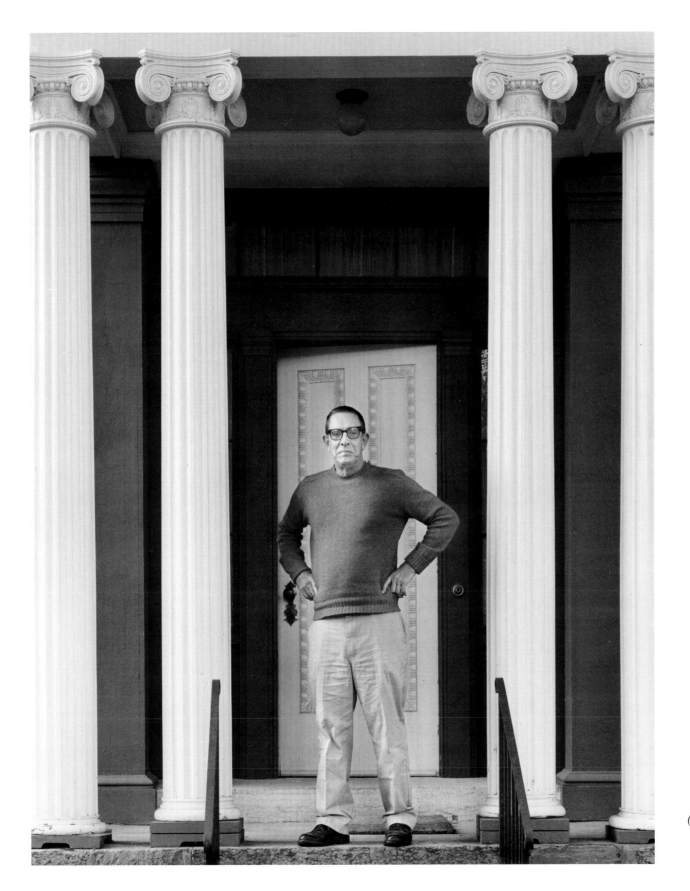

Lawyer, Commissioner

Adirondack Park Agency

Keene Valley, New York

September 1987

(interviewed October 1990)

WILLIAM J. SCHMIDT

I FIRST CAME to camp at sixteen years of age, from Mineola, Long Island," says Willie Schmidt, Camp Dudley's director since 1974. "It was the most important, significant thing that ever happened to me in my life." Chief therapist at the University of Pennsylvania Hospital and a trainer at the University of North Carolina, Schmidt turned down the job at Dudley three times before he said, "Let's go."

The oldest existing children's camp in the United States, Dudley was founded in 1885 by New York businessman Sumter Dudley, whose aim was to "get the kids out of the city . . . and give them a feeling of the presence of God." Located on Lake Champlain, Camp Dudley has room for about five hundred boys.

"I'm sensitive to other people's feelings," says Schmidt. "I'm usually not wrong. A few times I have been, but I can handle a kid pretty well. The kid that fools you is [the kid who] comes from a sophisticated area. But the kid from the inner city, they don't fool you—no facade at all. Probably the best kids I bring in are scholarship kids. There are ninety of them. I interview, basically, every kid that comes in here."

Schmidt contends that many kids have been influenced by Camp Dudley in their formative years as he was himself. "A camp is more than just fun and games," he says. "A camp is really a way of life. It's quite an inspiring place, it really is. We're teaching values. I really love what I'm doing."

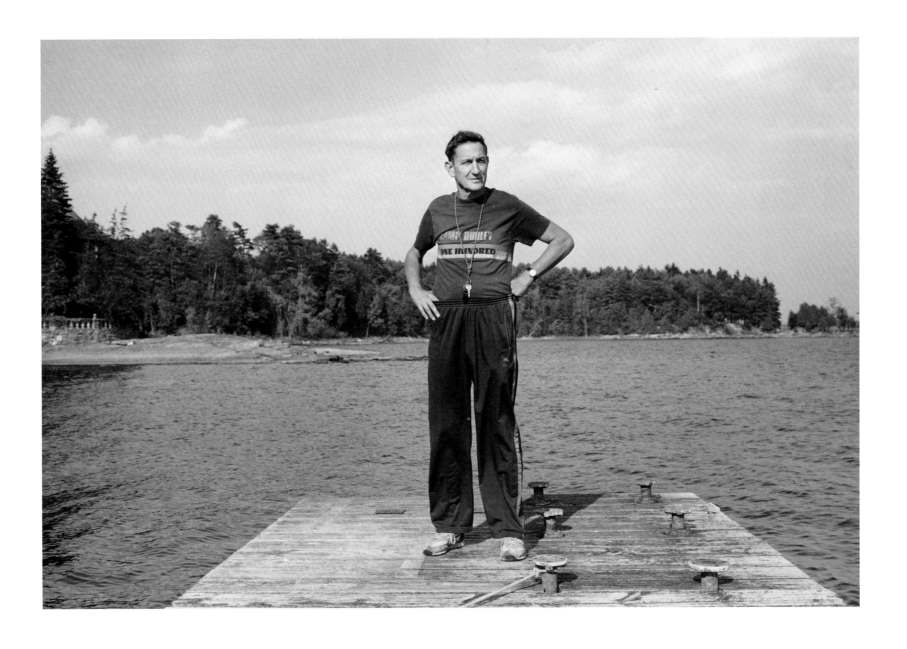

Physical Therapist,

Coach, Director Camp Dudley

Westport, New York

August 1987

CHESTER H. SCHWARZER

CHESTER SCHWARZER, who worked as a special installer for a large communications company in New York City, retired to the Adirondacks because he and his wife liked the climate and the scenery. "I first came to work for Santa's Workshop just more or less on a lark," he says. "I hemmed and hawed and before very long I found myself working as one of Santa's helpers in Santa's Workshop. One of the executives decided that I would look like a good Santa Claus and started to make motions as to the length of hair and the long beard, and it wasn't too long after that that I had long hair and beard. Needless to say, I was working as Santa.

"A child comes in and you ask them their name and age and little particularities about themselves and get them to speak of themselves. I ask if they've been good and if they help mommy and daddy and do chores around the house and ask, 'You don't throw your socks under the bed, do you?' and things of that sort. When they ask for something, you never promise them that you will give it to them. We will see what we can do for them. Santa Claus just cannot let people down. He can not!

"I don't use 'Ho,Ho,Ho' too often these days," says Schwarzer. "Years ago I did it a great deal more as there were fewer people I had to see, but now there are many, many people. The population has increased terribly. Well, I'm very happy about it, but it has just gotten around to the point that it got more commercialized with this 'Ho,Ho,Ho.' Everybody was using it so I've cut down on using it." When asked if children really thought he was Santa Claus, Schwarzer replied emphatically, "Santa Claus in Santa's Workshop is Santa Claus."

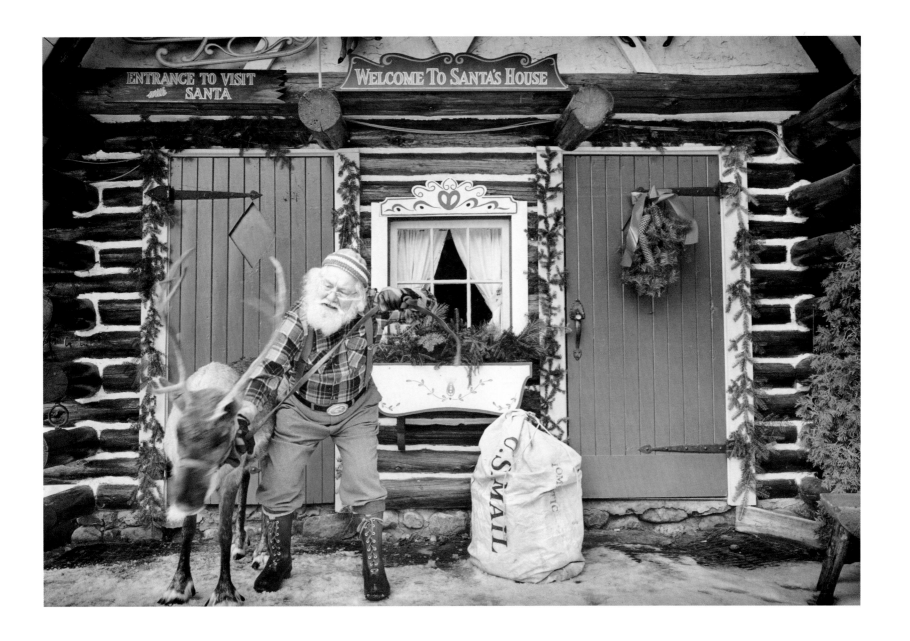

Santa Claus

North Pole, New York

December 1986

BILL SMITH

THE YOUNGEST of ten children, Bill Smith grew up on the last place on the road on a hill overlooking Colton, New York. "All the lumberjacks and all the hunters and the trappers and the guides would stop at our place on the way into the woods," he recalled. His mother would get up at 3:00 a.m. to bake pies and cakes and doughnuts for the lot.

Smith learned basketmaking from the Mohawk Indians of the St. Regis Reservation, who worked in the nearby woods as lumberjacks. "In the mud season, in the fly season, they would stop by and pound the ash trees and make baskets. And so I grew up around people makin' baskets from the time I was three or four years old. . . . Any time you asked them anything they wouldn't tell you anything. They'd say, oh, that's an old Indian trick. So you learned by watching.

"I knew a little bit about everything, I should say. I knew about farming, about cutting logs and pulp wood and stove wood and fire wood, and a little bit about cutting trails and marking trails, and a little bit about surveying, and a little bit about how to build things that were needed." One day Smith got mad at his boss and quit his construction job. "I started making baskets and snowshoes and canoe paddles and rustic furniture and whatever. And that's how I come to start workin' for myself. And the stories came about by hearing all these stories from the lumberjacks. And the songs, a lot of them, came from my mother, because [she] used to sing all the time. She was always singing, even when she was thinking. And at night it would be so lonesome, we'd sing to each other."

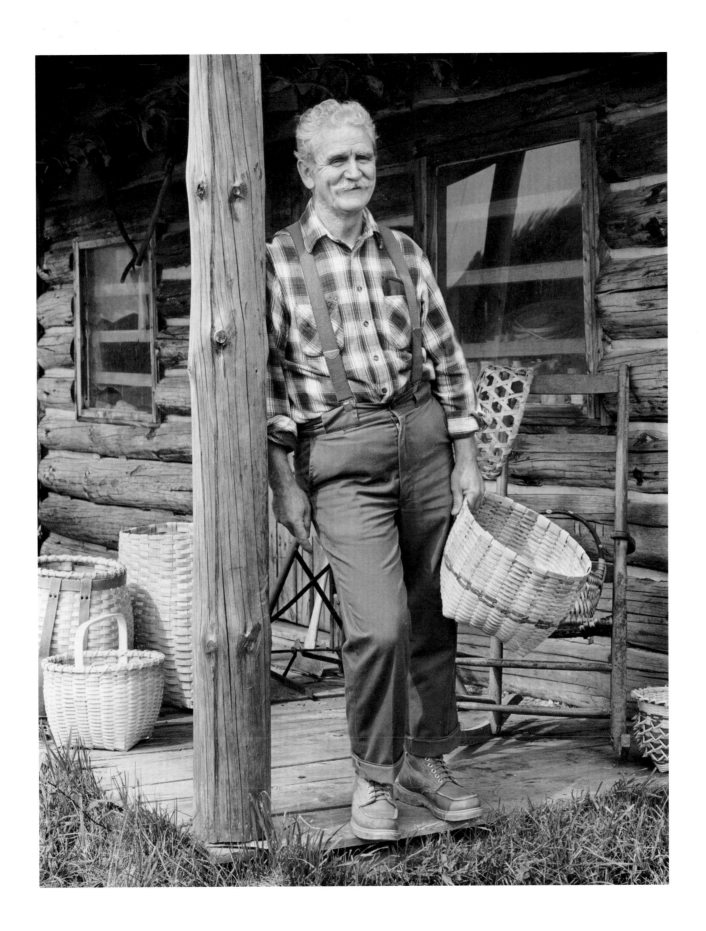

Basketmaker, Trapper,

Rustic Furniture Maker,

Storyteller, Ballad Singer

Colton, New York

September 1986

CONSTANCE B. SMITH

FORMER interior designer Connie Smith "got out of the mainstream of life" to run a general store in Forestport and "to get down to grass roots and find what real people were really like. I felt a love with what was going on rurally," she says. "We've had some great winters here—I can ski out my back door. I can swim out my back door. It's like living in a resort all year round."

An enthusiastic winter camper, she admits that "the natives get a little upset" when she traipses off in the woods alone with her skis and backpack. "I guess I'm not considered a native. I think you have to be born here. We've had a camp here since I was ten years old, and I consider myself a native since I've been paying taxes on it all this time."

Smith is learning to play bluegrass and country music on her violin as well as building up business in her store, which serves many community needs: "first-aid station, we've repaired bee stings and cuts; we're also real estate agent . . . and lost dog and cat depository. And we listen to a lot of people's problems.

"I'm not making too much money but I'm having a lot of fun. The joy of it is in seeing the kids grow up. I've seen a lot of them develop. It's like my own family." She adds, "I've changed my philosophy. I have decided that I'm going to do what I want to do a lot more than I ever did before. . . . I'm definitely not a money-oriented person. We've developed a new bumper sticker—I think I'll make some and sell them in the store. 'Born to give it away.' It's become my new philosophy of life."

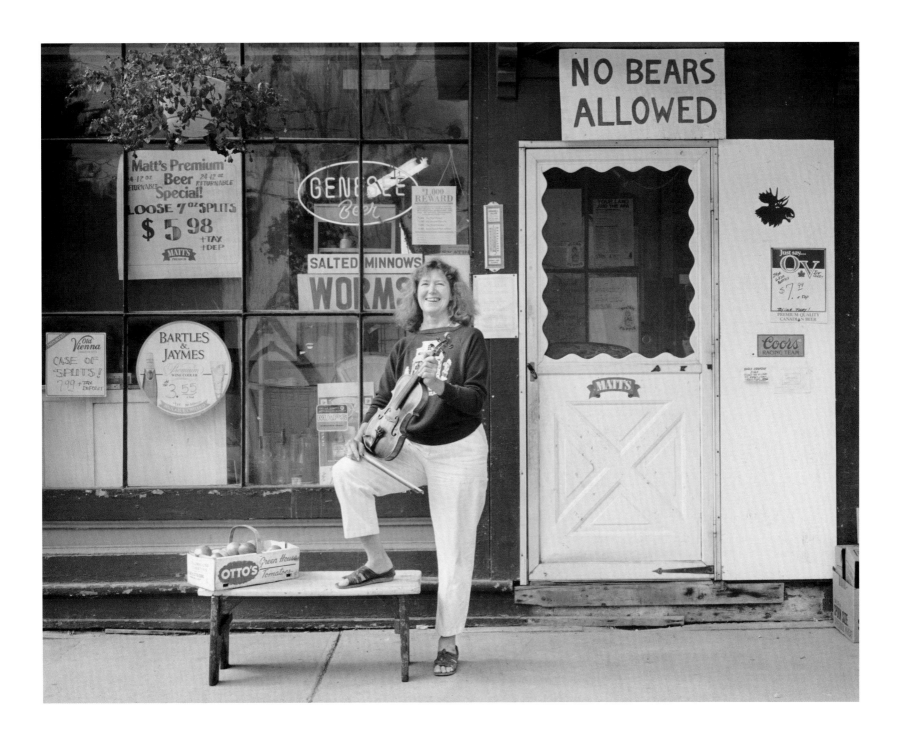

Storekeeper, Violin Player,

Artist, Outdoorswoman

Forestport, New York

August 1987

JACK L. SMITH

Born on a farm near Herkimer, Jack Smith has been making rustic furniture for about fourteen years. "I found a stick in the woods that I thought [would] make a great coat tree and so I made it. And I thought I'd invented rustic furniture. And then I wanted a plant stand . . . and made lots of plant stands, and it's just been growing."

Working at Sagamore, a great camp built by William West Durant, is Smith's idea of utopia. "Everything's made from my heart," he says. "Sometimes you have to do what the stick wants to do. You have to release what's hiding in there." He points to a piece of wood. "That one was growing around the stump, and so I took a day to dig the stump away and cut all the roots loose—you knew what it was. What it was going to be. 'Release me, make me into this seat.'" He adds, "And he looks like he's going to walk back into the forest."

When asked if he wanted to get closer to nature, Jack Smith replied, "No, I don't have to get closer. I'm part of it. Most people have forgot that they're part of it. I just like the hills, the mountains, and the trees, and I believe the way the critters live is the way humans should be living now."

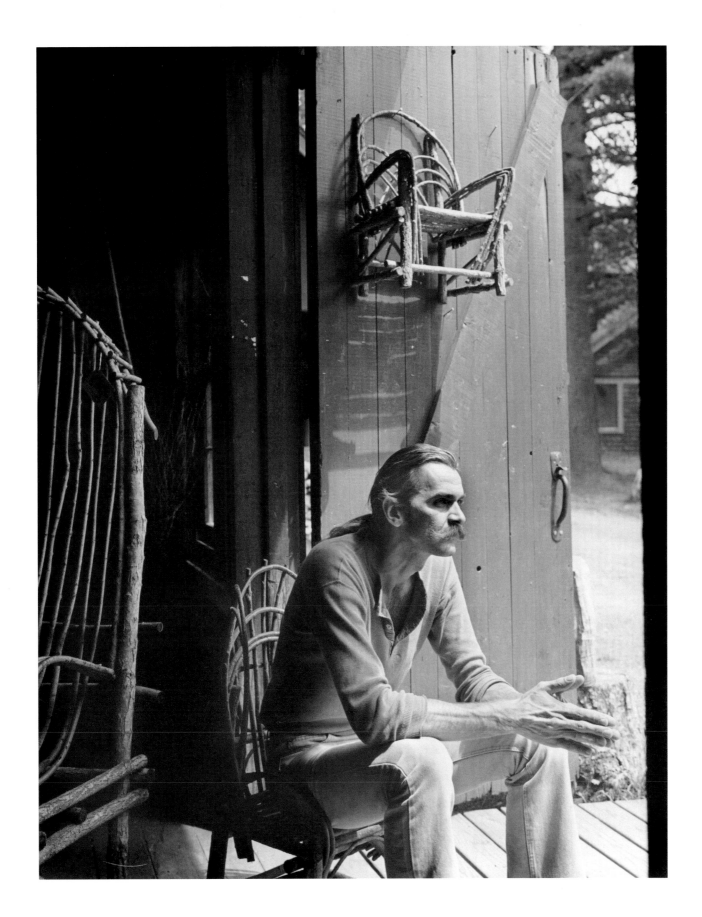

Rustic Furniture Maker

Raquette Lake, New York

July 1987

RICHARD STEWART

RICHARD STEWART'S grandfather married a Hitchcock, the daughter of the family that settled the Bakers Mills area in the early 1800s. Stewart and other family members shared the house belonging to his grandparents, who farmed and raised their own meat and vegetables. "We lived like a clan," he says. "In the wintertime we had an average of a thousand quarts of vegetables canned . . . forty bushels of potatoes in the cellar. My grandmother would put the hams in the crock and put enough salt in the water to float an egg. And then she put brown sugar and spices proportional to the amount of salt, and she soaked the hams in the brine, and then she smoked 'em with corncobs. And we went to school in Sodom . . . in a one-room schoolhouse out there."

Stewart got into beekeeping when, with aid of a compass, he began to track the bees that clustered on his garden poppies to their hive in the woods. "I've followed some bees as far as a mile and a half. Usually the bees won't go over a mountain. I carry a hive and my bee suit and my smoker and my saw and axe into the woods. I take the brood out of the tree and I cut the cone so it fits the frame of my hive and I wire 'em in and I scoop up hands full of bees and put 'em on the cone and hopefully I get the queen at the same time. . . . If you see the bees going into the hive and a whole bunch of bees standing at the front of the hive fanning their wings with their rear ends up in the air, then you're pretty sure that the queen is in the hive. That's the signal for other bees to come to their new home.

"There's one thing about being poor," he says, "you learn to be diversified. We were considered poor because everything that we owned we paid for, and we didn't ask for credit. This house was handed down from generation to generation, so we didn't have any mortgage payment to make on it. But it was a thing of pride, too. If you didn't owe any-body anything, then you felt that you were free."

Stewart was thirty-five before he traveled more than a hundred miles from North Creek. "Then I went down to New York City for a week and I was glad to get back here."

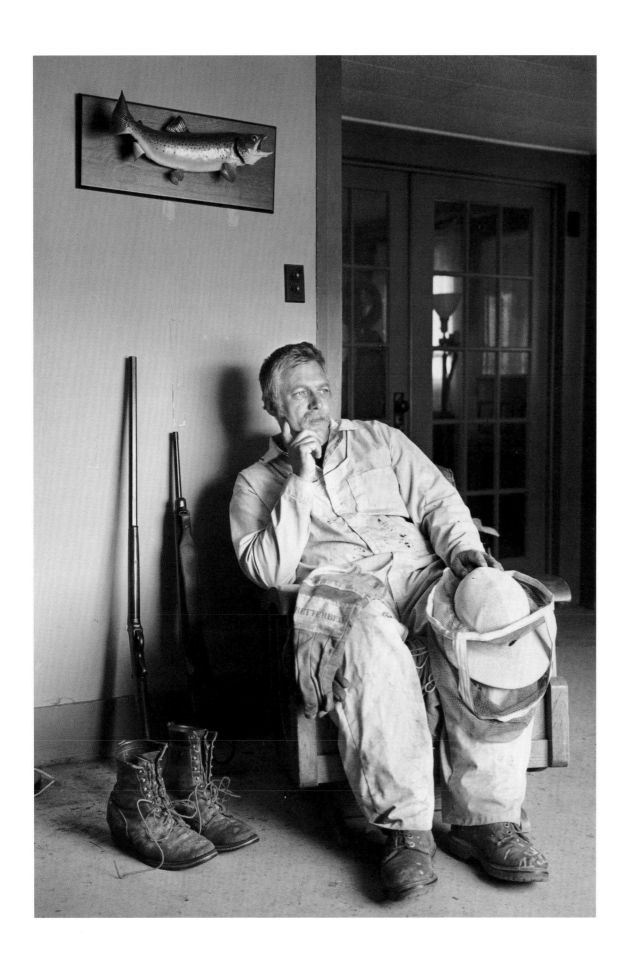

Beekeeper,

Farmer, Carpenter

North Creek, New York

August 1987

BEN STOCKLOSA

THE STOCKLOSA FAMILY, who live just west of the Blue Line in Boonville, camp out in the Adirondack Park regularly. "I'm out here in the Adirondacks just relaxing and taking it easy," says Ben's father, Tom Stocklosa, a carpenter and deer farmer. "You can sit back and enjoy nature and get away from the pressures of life at home. At least you know [the kids] will be safe. It gives them a place to run around.

"We hike and we've done fishing, and there's bicycling. We have a tandem bicycle with a seat on the back for my younger son, and my older son has got his own bicycle, and we kind of bicycle around the park instead of getting in the car and taking a ride around. Different campsites offer different things, and you just go for what you want."

Boonville, according to Stocklosa, "hasn't changed like most of the places in the United States." Its population has actually declined since the 1860s, when the canal system connecting lakes and towns in upstate New York was completed. Boonville "was probably the high point in the canal system," Stocklosa maintains. "Before the automobile, the canal was the only way. [Today] there's very low growth and very little opportunity for people growing up here. Boonville's going to end up to be a town where people retire at."

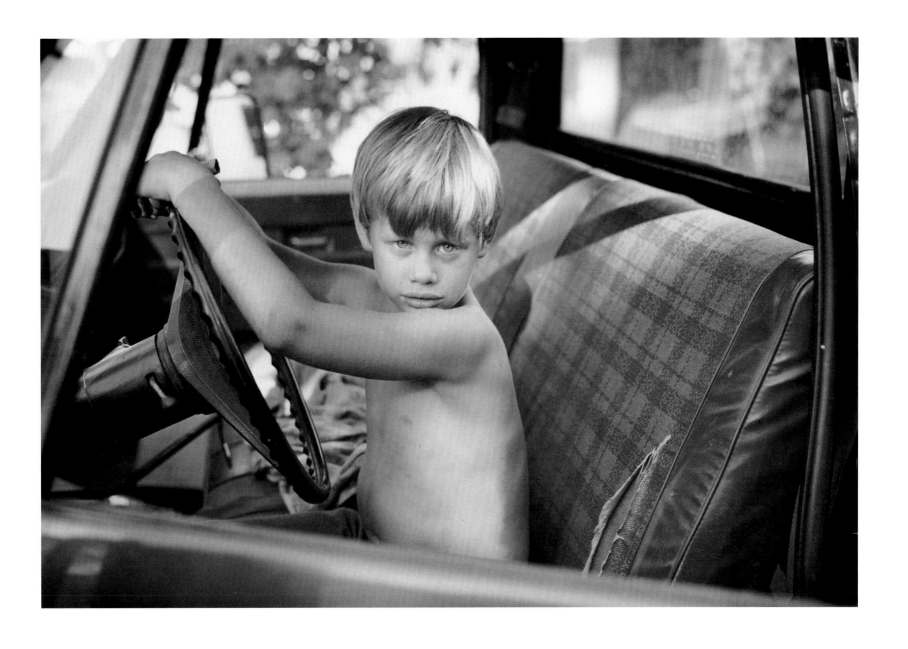

Student, Cub Scout, Bicyclist

Boonville, New York

August 1987

LINDA STURTEVANT

LINDA STURTEVANT, who came as a clerk in 1975, has run the post office in Wood-gate since 1981, when her predecessor, Ruth Rubyor, retired after serving thirty-six years. Ruth's mother, who came over from England in 1918, started the general store and in 1925 combined it with the post office. Although there are as many or more women running post offices in the Adirondacks, the title *postmaster* applies to all. There is usually a list of people waiting "to get" a particular post office, a steady job with good benefits and long tenure for the person who fills it.

The general store and post office, a combination no longer typical of the Adiron-dacks, serves as social center and community clearing house. "People are always leaving notes for someone," says Rubyor. According to Sturtevant, "They all come and catch up on the gossip. People meet here in the morning, get their mail, pick up the milk or something, and kind of stick around and see what's goin' on."

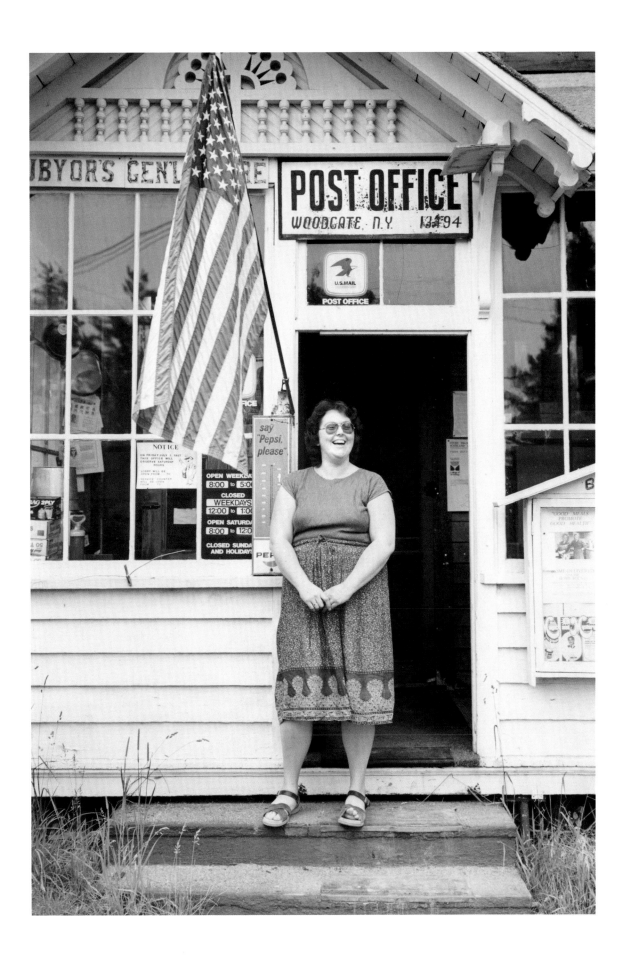

Postmaster

Woodgate, New York

June 1987

THOMAS F. SULLIVAN

I'VE ALWAYS WANTED to be a monk in a monastery," says Tom Sullivan. "But I realize that I need to be around people some of the time because what I really think I'm called to do is to challenge the bureaucracy. Challenge the lack of justice, challenge the inability of people to wholeheartedly care about somebody else. Caring is an art. A person finds himself constantly anticipating someone's needs. . . . Every day is a constant challenge for me to stay on course with these ideas." He adds, "People are almost compelled to dislike another person for living in solitude, you know."

Born in New York City, Sullivan came to the Adirondacks when he was eleven and later left for twenty years. He returned again, from Alaska and the West, in the early 1980s. "Beautiful country in Montana," he says. "Beautiful country in the high Rockies. But I think to deal with people and to deal with nature, the Adirondacks has a very nice offering for somebody who really wants to combine a meditative life—a contemplative life—and an active life. I see myself trying to do that."

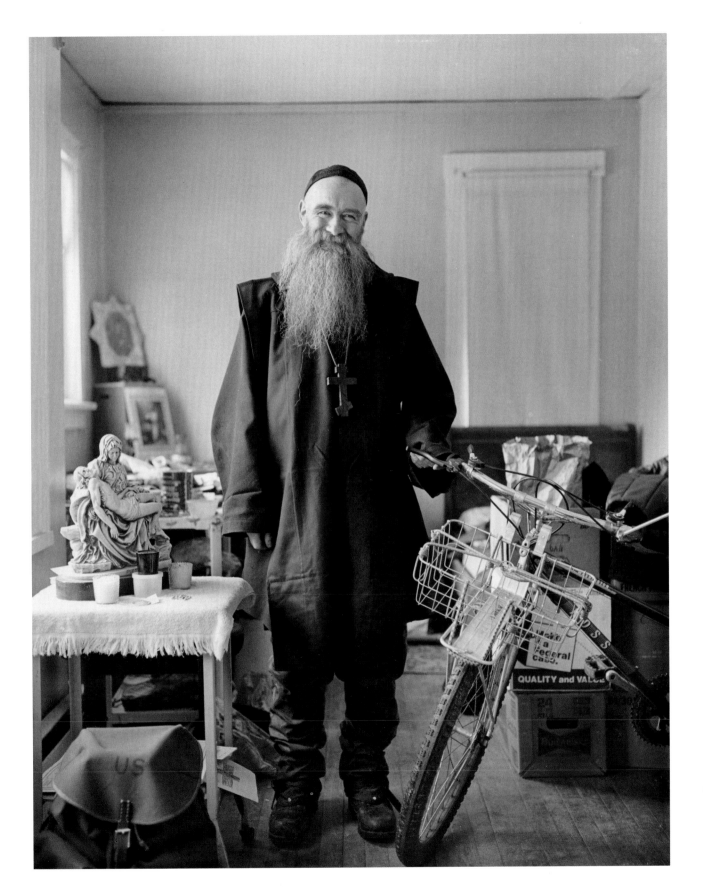

"Monk"

Saranac Lake, New York

December 1986

KENNETH THIBADO

Ken thibado, a center fielder on the undefeated Inlet Mets, is a student at the Town of Webb Central School. In the summer he operates his family's laundromat in Eagle Bay. "What I do here all day is I clean lint, I clean lint traps in the dryers. I wash out the washers when people are done with them. I read and help out people. We have a change machine, so that helps them a lot. And when the dollar's not accepting, well I give 'em a new dollar in trade for that one." After baseball practice, he and his friends go to the Arcade to play games and chew bubblegum.

In the winter, Ken says, the snowmobilers come to town on the weekends "from all over the place," even Florida. The town likes them "because that's good business." But he adds, "Most of the time the people up here go to warm places."

Four generations of Ken's family have grown up in the Eagle Bay and Old Forge area. Ken's father, Tom, is a builder, as were his father and grandfather. Ken's great-grandfathers on both sides of the family were among the first guides in the area.

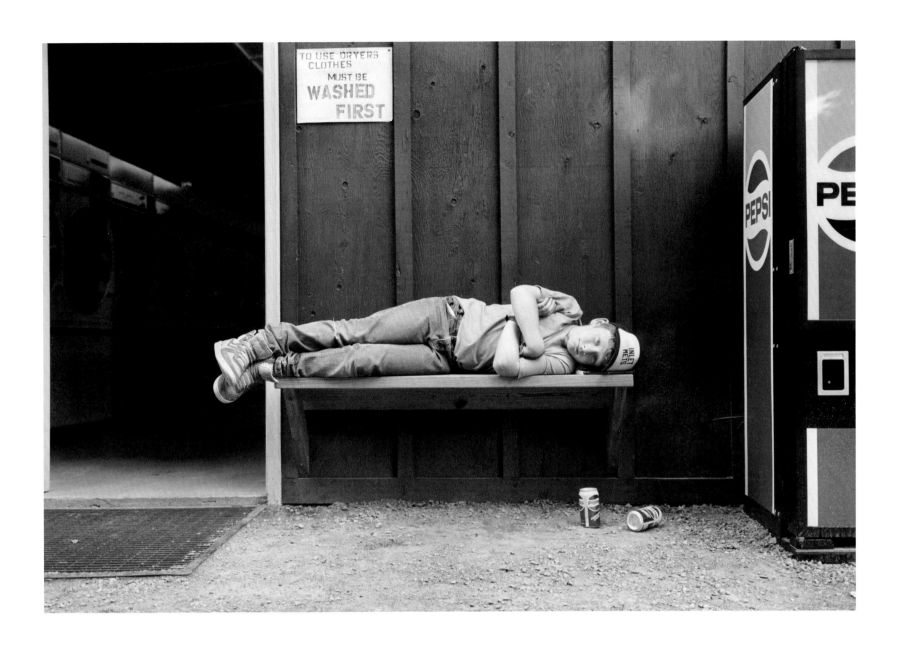

Student, Little League Player,

Laundromat Operator

Eagle Bay, New York

July 1987

EDWARD E. WHITE

Live simply . . . that's my whole theory on life," says Edward E. White, who is a third-generation Adirondacker. His idea is to imitate as closely as possible the type of subsistence farming typical of the Adirondacks in the nineteenth century, supplementing his needs with menial jobs. "Sort of appreciate what the settlers went through. We try to be as Early American as possible. We have some modern conveniences, you know, electricity and stuff. Our goal was to clear and homestead the land, raising small animals for our own self-sufficiency. I'd like to have the sort of job," he continues, "that's seasonally where I can get back to this type of life through the fall and winter, with the trapping and snowshoeing and stuff. Money doesn't mean a lot to me except when I need to pay something. Having a brand-new car to keep up with the guy next door, that doesn't turn me on."

Ed and his wife spent a winter in their partially built log cabin, something he had wanted since high school and helped build. "We would see right through to the basement floor. Her and I'd come out here and drink coffee by the wood stove, huddle in our overcoats before we went to work. We went from total inconvenience . . . like the pioneers did. I mean we were cold. And her and I huddle on the couch, you know, wrapped up watchin' TV. Really we went through a lot of hardships. I like the hardship. It gives you that challenge in life."

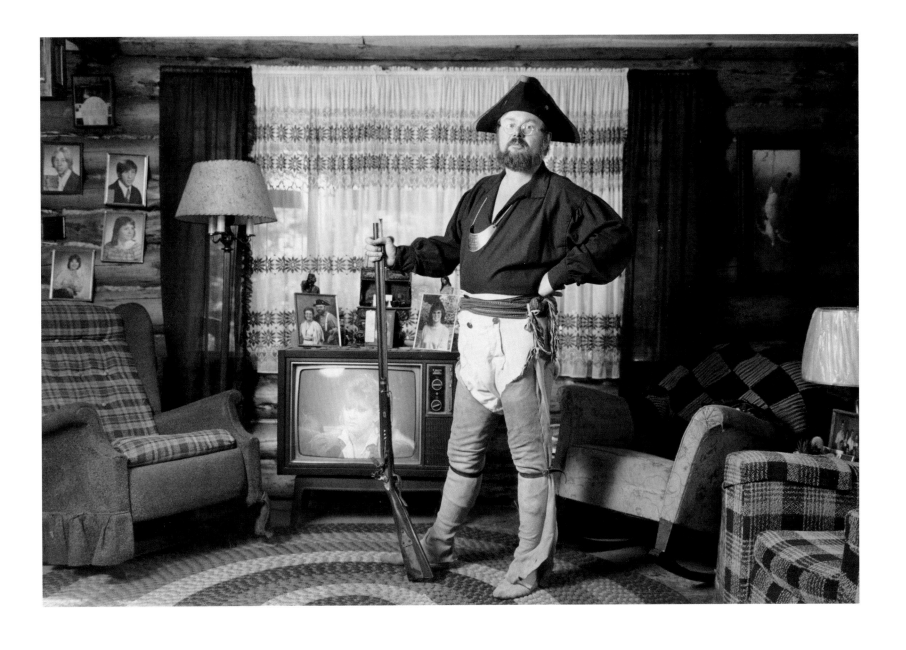

"Mountain Man," Logger, Carpenter, Mason

Caroga Lake, New York

August 1987

AFTERWORD

Mathias Oppersdorff

We are in Jim Latour's sawmill, and I am trying to take his picture. It is twenty below, and the gusts of icy wind blasting through the open-sided shed have just tipped over my strobe for the second time. I start again and quickly take a few exposures. I ask Jim to put his hand on the teeth of the huge circular saw blade. I like the element of danger. Although I have his total cooperation for the "sitting," I hardly have ten minutes to do my work. The cold makes spending more time with him too painful.

In August 1986 I learned that I had been selected from among eighty-six competitors by the Adirondack Museum to photograph the people of the Adirondack Park and also to interview them. The resulting images would be displayed by the museum in 1989 and then be exhibited throughout the state; the interviews and photographs would be used eventually for a book. Other than those few directives, I was left to do my own choosing. I could go anywhere and photograph anyone I wanted.

For gathering visual documentation I used a six-by-seven Makina or a six-by-nine Fuji and a hand-held light meter. I liked the medium format for its combination of mobility and superior print quality. Occasionally I used a tripod, sometimes a strobe, and rarely a six-by-nine view camera. My film was Professional Tri-X rated at ASA 200. I did all the prints on Agfa Portriga Paper and the oral interviews on a small Nagra SNN tape recorder.

Although everyone was supportive of my commission, it was difficult to meet someone for the first time and come away in less than an hour with a photograph good enough to hang on a museum wall. Most portrait photographers like to take time with their subjects. In my case I was obliged to set the mood necessary to have good results "happen" at once and often under tough conditions. From the beginning I wanted to place my subjects in their own surroundings. In this way I could show a face and let the environment add to our insight as to how each person lived and worked. I met all my subjects on their own ground—in the sawmill and out in the fields.

At first I covered great distances without much luck. I then realized that "the hurrier I went" the less I saw. If I were to find the subjects I wanted, those who seemed to epitomize the Adirondacks in some way, I would have to spend time in a community and simply feel my way around. Soon I was finding subjects everywhere. In some instances

I would stumble across one, but most of my "discoveries" were people I heard about from someone else. Usually I contacted potential subjects first by telephone if they had one, with no idea what they looked like. For example, I heard about Bill Bibby from a restaurant owner in North Creek. I happened to mention that I was looking for a railroad man—perhaps some sort of "Railroad Bill" with steel-rimmed glasses and the right kind of overalls. So I was sent over to Mr. Bibby, Sr., a retired railroad man with many decades of service. He in turn sent me to his son, who was not only named Bill but also looked the part. Bill was both an enthusiastic spokesman for the Adirondacks and a champion tobacco spitter.

Another lucky find was the Reverend Daisy Allen. I first met the Reverend Daisy when I photographed her husband Earl and his handmade rakes. She treated me to her homemade cookies and some of her wisdom as well. The Reverend Daisy's idea of caring for one's neighbor was not to wait for others to solve the problem but to devote her own time sitting by the lonely or sick, until dawn if need be. I was amazed at how the people I met cared for their neighbors and how their neighbors cared for them. When Katie Cross lost her husband and her house in a fire, the whole community pitched in and built her a new house.

The more I met and photographed people like these, the more I wanted to look for others like them. They weren't that hard to find. And I realized that there was a type of magic happening. Perhaps at some level they chose me just as I chose them.

There are a great many people to whom I owe thanks for the support of this project. Among these are the people of the Adirondacks themselves, my photographic subjects and countless others who helped me along the way. Special thanks go to the following: Adam Hochschild, whose vision made this project possible; Craig Gilborn for his guidance and incredible patience when the project stretched out much longer than it was supposed to; Alice Gilborn for dealing with the lengthy transcripts of my interviews; Harriet Barlow and Kaye Burnett for creating a home for me at Eagles Nest; and Evelyn Thompson, who did the cooking. I also want to thank Gilbert and Ildico Butler of Alder Creek, who were my ever-enthusiastic hosts in the western part of the Adirondacks; Nathan Farb of the High Peaks region, who was always supportive of my work; and Betsy Folwell of Blue Mountain Lake, who steered me toward some very good subjects.

On the home front I want to thank Irwin of Scope Associates, New York City, for developing the negatives, Glenna Goulet for transcribing the interviews, and my friend Sal Lopes, whose darkroom advice was worth listening to. And I won't forget W.E.R. and Marty LaFarge and Lucy Hodgson, who encouraged me from the very beginning.

ABOUT THE AUTHORS

MATHIAS OPPERSDORFF, an international photographer, is regularly employed by *Gourmet* magazine. His photographs have also appeared in *GEO, Natural History,* and *Diversion.* His traveling exhibit "Adirondack Faces," containing the portraits in this book, opened at the Adirondack Museum in May 1989 and was widely acclaimed.

Mathias Oppersdorff's noncommercial work has included photographic studies of the people of the Arabian peninsula and a roving group of Irish known as Tinkers. Besides travel and photography, he is interested in wildlife conservation. In 1981, he helped secure federal funds for the expansion of the Trustom Pond National Wildlife Refuge in Rhode Island, not far from his home and darkroom in Wakefield.

ALICE WOLF GILBORN, born and raised on the outskirts of Denver, Colorado, has lived since 1972 with her husband Craig in Blue Mountain Lake in the central Adirondacks, where they have raised their two children. In 1979 she founded the literary magazine *Blueline,* featuring Adirondack poetry and prose, which was transferred to the English department at Potsdam College in 1988. She has written numerous essays and articles on Adirondack subjects, and since 1985 has been editor of books and publications at the Adirondack Museum.

An experienced horseback rider, Alice Gilborn and her daughter, Amanda, age ten, joined her eighty-two-year-old mother in Colorado in August 1990 for a two-day competitive trail ride on muleback. She tells the story of her mother, Cee Wolf, and her own upbringing on a ten-acre farm with sixty-four animals in her 1976 book *What Do You Do with a Kinkajou?*

ADAM HOCHSCHILD, founding editor of *Mother Jones* magazine and author of *The Mirror of Midnight: A South African Journey,* has spent much time in the Adirondacks since his childhood. He wrote about Blue Mountain Lake in his 1986 book *Half the Way Home.*

Adirondack Faces

was composed in 12.5 on 16 Baskerville II with display
type in Frutiger Ultra Bold on 8600 Digital Compugraphic
equipment by Connell-Zeko Type & Graphics Inc.; printed
by sheet-fed offset on 80-pound, acid-free Westvaco
Sterling Satin by Southeastern Printing Company; and
Smyth-sewn and bound over binder's boards in ICG
Arrestox B, with Strathmore Grandee endpapers by
Nicholstone Bindery; with dust jackets and endpapers
printed by Southeastern Printing Company; design
and production by Ed King, Hillside Studio;
and published by
**The Adirondack Museum and
Syracuse University Press**
Syracuse, New York 13244-5160

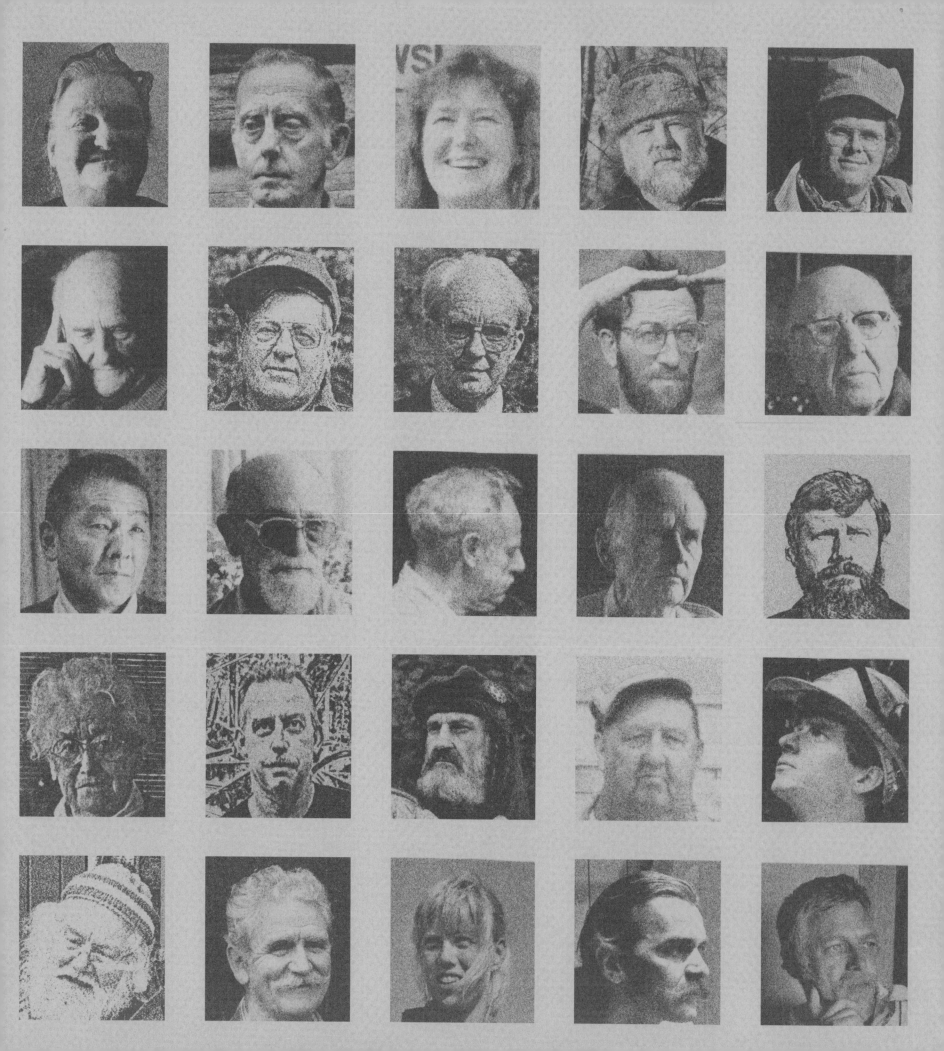